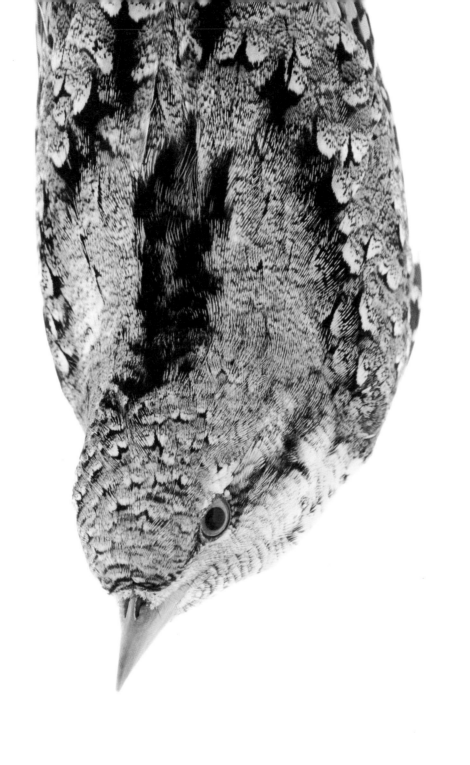

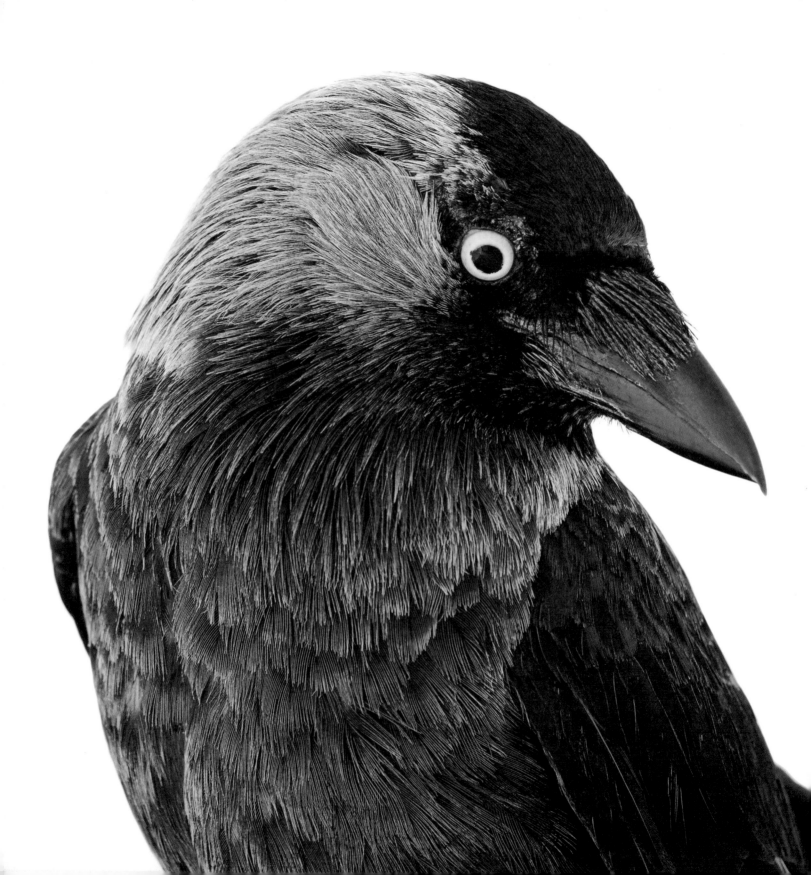

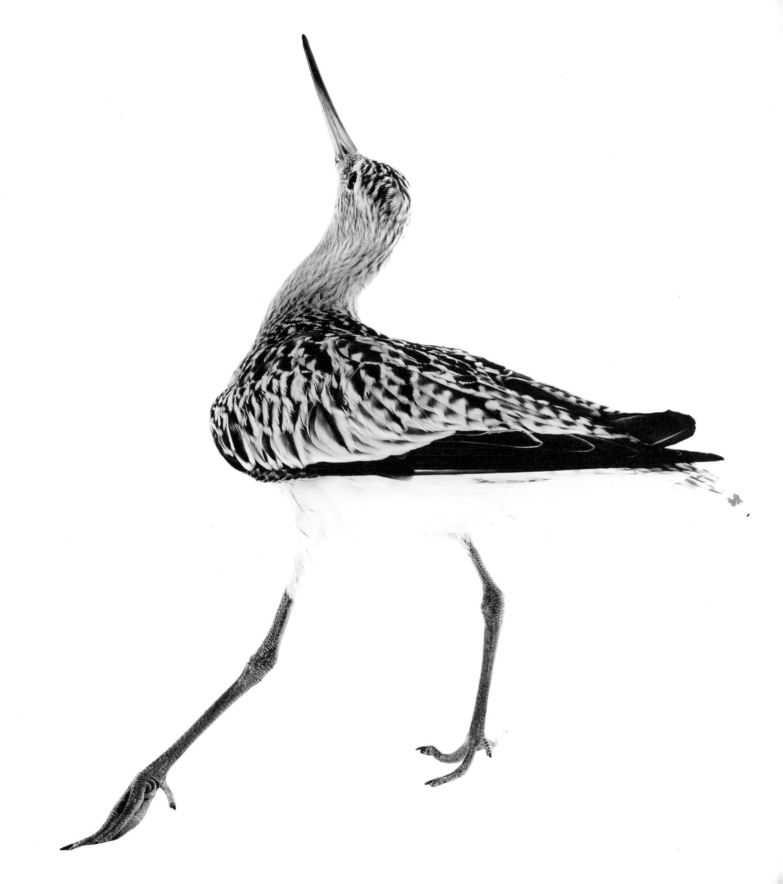

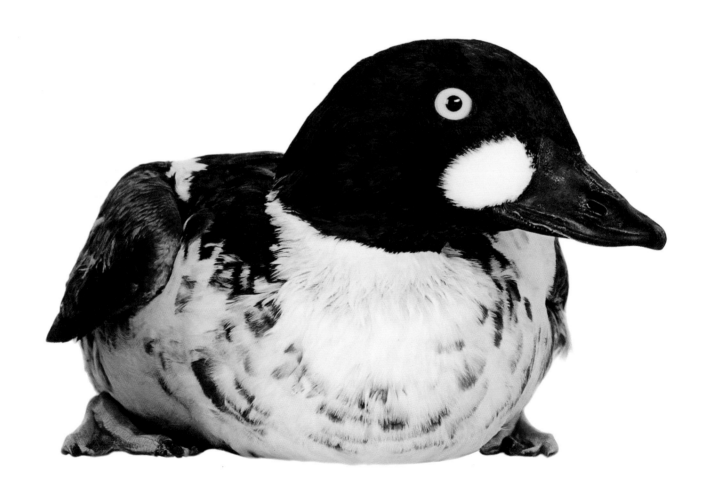

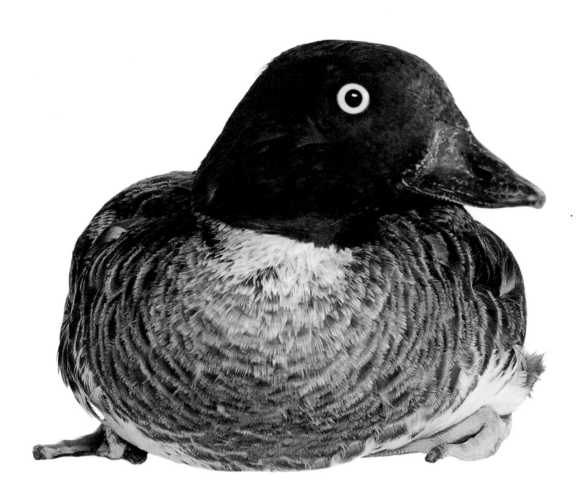

COMMON GULL

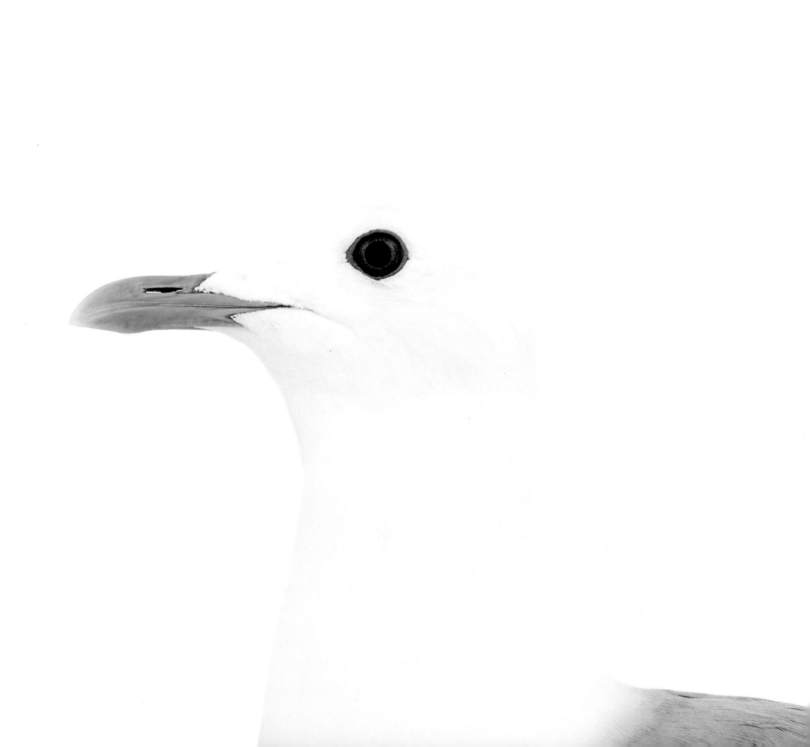

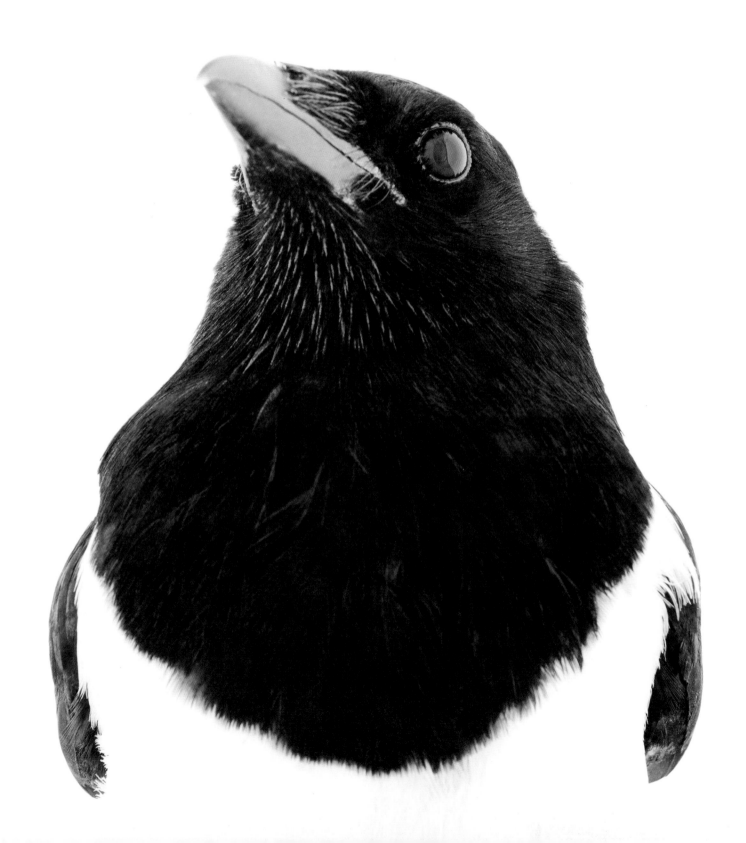

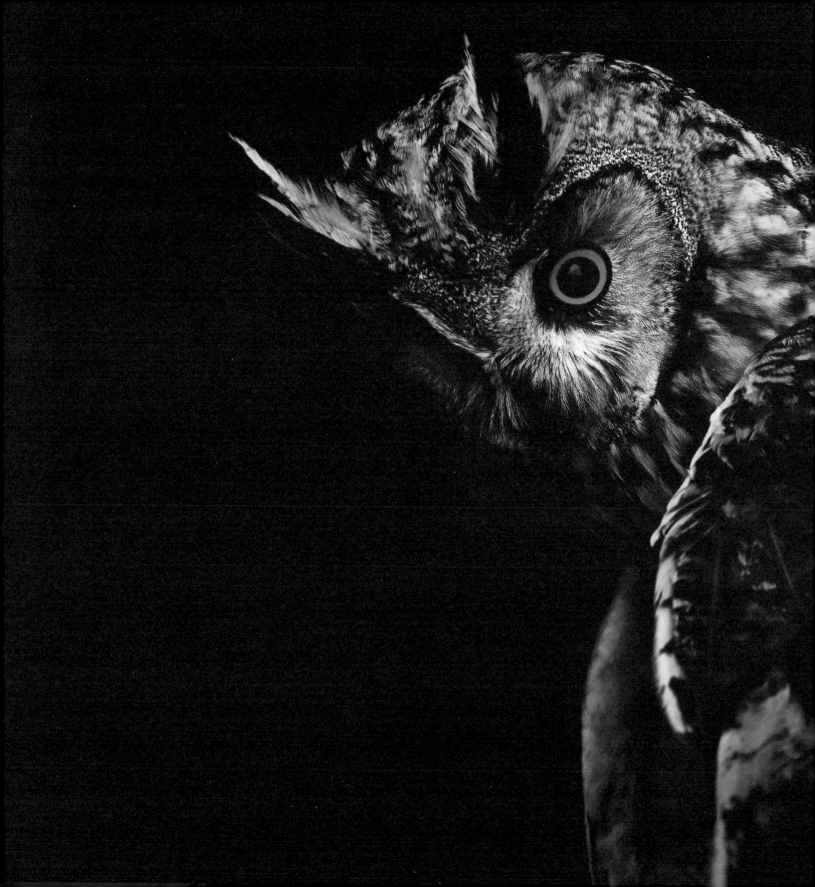

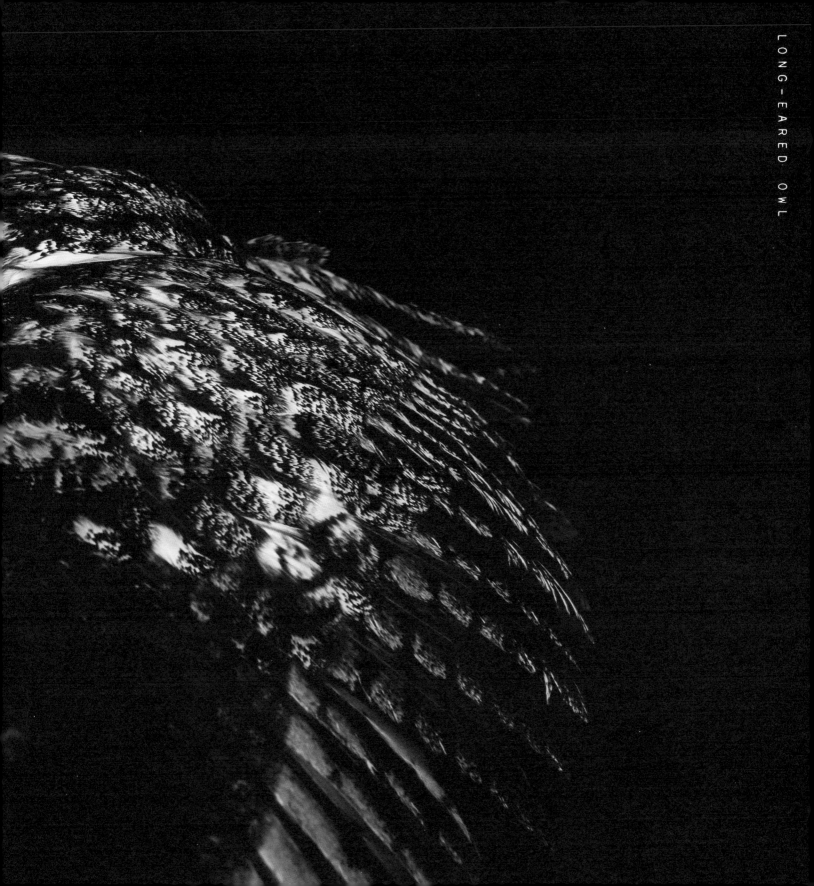

CLOSE TO BIRDS

AN INTIMATE LOOK AT
OUR FEATHERED FRIENDS

PHOTOGRAPHS BY ROINE MAGNUSSON

TEXT BY MATS OTTOSSON
AND ÅSA OTTOSSON

TRANSLATION BY KIRA JOSEFSSON

ROOST BOOKS

CONTENTS

$$\frac{\times}{1}$$

WHY BIRDS?

A constellation of starlings swoop between the enclosures at Twycross Zoo in England, unconcerned, as birds tend to be, with walls and fences. Suddenly, one of them hits a glass pane with a bang and falls to the ground inside the bonobo enclosure. Kuni, a female ape, walks up to the lifeless body and carefully tries to make it stand again, without success. She attempts a soft toss instead, but the bird just flutters its wings confusedly before thudding to the ground again. Finally, the ape takes the starling and climbs the tallest tree in the enclosure, holding on to the trunk with her feet so that her hands are free. She spreads the wings of the bird and releases it like a toy plane.

Our closest animal relatives can't help but be touched by birds—quite like us.

The story about Kuni and the starling (which in the end recovered and was able to fly off without assistance) is recounted in primate researcher Frans de Waal's book *Our Inner Ape*. Though his intent is to illustrate the compassionate nature of bonobos, one can't help but be struck by the monkey's sensitivity to the bird's being. How old is our fascination with birds? Are the roots of these feelings deep enough that they reach past the point where our family tree branched off from that of chimpanzees and bonobos, seven million years ago?

A single anecdote about one monkey's behavior is of course not enough to construct a theory, and the question remains unanswered. But we'll

keep this image of the bonobo in the treetop with us, as a symbol for the depth of the simple claim we are about to consider: that birds touch us.

No other wild animal can waken the curiosity, warm the heart, and quicken the pulse of so many of us. No other wild animal is as close to our hearts.

We want to tell you about all of this: about birdsong inspiring comfort and joy, bird flight rousing dreams of freedom, bird presence giving life and character to seasons and landscapes.

We are not the only ones talking about birds right now. Interest in birding is growing; $3,000 binoculars are flying off the shelves, and rare bird sightings—along with the curious behavior of the ambulating human spectators—are granted ample space in the media.

But the public eye tends to focus on a *certain type* of bird-spotting, where practitioners chase new thrills and rare birds, and put a strong emphasis on knowledge of detail. In order to separate the exceptional from the commonplace, you do need meticulous attention to fleeting mating calls and the fine print of plumage. How else are you going to distinguish a rare dusky warbler from an ordinary—and nearly identical—willow warbler? How else could you tell which one of the gulls at the dump is average and which one is a sensation?

Granted, we who have made this book own spotting scopes, do our best to remember what distinguishes one species from another, and are

delighted when we see a bird we've never seen before. But this book is meant to be about something else. We are not looking to understand the attraction of rarities. To the extent that this book is about bird-watching it's about the kind of birding Kathleen Jamie describes in her lovely book *Findings*: "Between the laundry and fetching the kids from school, that's how birds enter my life. I listen. During a lull in traffic, oyster catchers."

We are not setting out to comprehend why birders are interested in rare birds. We are more curious about why basically every human being is moved by the most commonplace bird encounters: the eyes of a robin, the great tit pecking at the windowpane when the feeder has run out of seeds, the white hieroglyphs of gulls against the summer sky.

Why birds?

The photographs in this book give *one* obvious answer: birds are beautiful. This is true not just for the Eurasian blue tit with its gemstone sparkle or the heraldic golden eagle. Witness the shades of brown on the Eurasian tree sparrow! The blue on the back of the Eurasian nuthatch! When you get close enough to see every shade, every serif of the moiré-patterned feather, it's clear that not just the handsome birds are beautiful. It becomes obvious there are no mediocre species.

Henceforth, we will leave it to the photographs to show the birds' colors and shapes. Instead, we want to focus our words on that which the camera can't entirely capture, traits that characterize the birds to an even greater degree than their exterior signs.

THE SOUND OF BIRDS

There was a time when the birds sang just for us.

Or, rather, there was a time when we thought the very purpose of bird-song was for humankind to enjoy themselves. According to the bards of romanticism and religious authority figures, a higher power had been kind enough to outfit the birds with singing voices for our pleasure.

Today we know better. Birds couldn't care less about the inner lives of humans; they sing for each other. But just because science has lifted the veil of romanticism and religion doesn't mean the birds' ability to communicate is any less incredible. Quite the contrary: the more we understand, the more fascinating it is.

As mating season approaches, the very physicality of the singing male changes. The parts of the brain that contain the song control system grow bigger, making the impulses to sing for a mate impossible to resist. Whether the male understands, in the sense that humans tend to think of understanding, what he does and why is of course irrelevant. Do *we* even know why we sing all the time? What matters is that he understands, in the way of birds, that it is time. And how he sings, then! A Finnish scientist who pursued one male European pied flycatcher found that it sang 3,620 times in 24 hours. It's said that a male great reed warbler can repeat its loud melody 10,000 times in the same time period.

Their message: *Here I am, hear my might!* The intended recipients—other birds of the same species—have entirely different responses

depending on if they're male or female. Studies have shown that the brain of a female bird acts like the brain of a human enjoying a favorite piece of music, whereas a male bird's brain reacts to the song of his competitor as humans do when we listen to a loud racket.

The female hears a seductive *Pick me!*, the male a threatening *Scram!*

Birdsong is more complex than we can even perceive. The bird throat's sound-producing organ is constructed such that the bird is able to sing two separate tones at once, allowing it to duet with itself. Moreover, the speed of the song—indeed, of the bird's whole life—is so fast that we are unable to grasp all the details and nuances. The so-called temporal resolution is less good in humans. The pace of our lives is so slow compared to the birds that we can't keep up. It's like our hearing is blurred. Only when we record the song of the birds and play it back at a lower speed can we understand the full extent of their sound art.

This is of course proof as good as any that they're not singing for us.

But even though we're not the intended recipients, the song can still be striking to us—striking and resonant.

In a heartfelt ode to the song of the inconspicuous Bachman's sparrow, the American ornithologist William Leon Dawson wrote that hearing it gave him butterflies and made him want to take off his shoes.

It's not necessary to be familiar with this particular bird's song to recognize the sentiment. That's exactly how it feels. The first skylark in

the spring. The curlew! The mildly inquiring diphthongs of a coastal eider in April, like it's gotten lost: *Aou? Aou?* Hearing it makes you want to throw something off: your shoes, your clothes, your sorrows.

Is there *any* other intentionally created sound, aside from those we make ourselves, that moves us as powerfully as birdsong? Whale song is fascinating, but these sounds reverberate in a foreign world. We can only access it through recordings, and that's not the same. The howls of the wolf—yes, there's a power there. The buzzing of the bumblebee and the whirring of the grasshopper and the cricket bring intense summer feelings. Farther south, cicadas and frogs provide a suggestive and strong (sometimes almost painfully strong) reminder that you're somewhere warm and humid.

But birds are singular.

Every now and then, you'll find aesthetically inclined naturalists furrowing their brows to determine what bird has the most beautiful song. Tastes diverge, of course, and you might be able to discern both personal and cultural differences. Brits usually rate the nightingale at the top, Swedes the blackbird.

In his book *Birdsong: A Theme with Variations*, Staffan Börjesson went one step above just ranking the sounds. He wrote a proper review of the song of each bird, stylized in a way that wouldn't be out of place in the culture section of a newspaper. The limitation of the song

thrush is that it "rarely manages to sustain the magic for more than a few seconds." The marsh warbler "often exhibits a potential not fully realized."

It's an entertaining read, and frequently on point. But the question is how much musical brilliance matters. The birds' ability to move us with their song seems to stem from entirely different factors. Is there really any musicality in the call of the crane or the lowing foghorn thrusts of the Eurasian eagle owl? Or take the sharp cries of the common swift— hardly a beautiful melody, but they do strike a heart hungry for summer.

It's obvious that other factors play at least as big of a role in our love of birdsong as the bird's singing skills: The location. The context. The resonance of one's own memories. An experience is enhanced when past landscapes meet contemporary ones. When the song lark's jubilant melody above the field also speaks of springs past. When your childhood's curlew is folded into the one you hear as you walk over the meadows to the river. When you hear the laughter of the willow ptarmigan through your ancestors' ears as you traverse the reindeer fields. When dawn's blackbird is chirping from the rooftops like it did when you were twenty and in love, stumbling home on a late summer night that imperceptibly had shifted to early morning.

THE FLIGHT OF BIRDS

All that volley of speed, those convolutions of delight, to catch a few flies!
—NAN SHEPHERD on the flight of swifts in *The Living Mountain*

Barry Lopez's short story "Emory Bear Hands' Birds" takes place in one of the most constrained environments imaginable: an American prison. With some reluctance, the Native American Emory Bear Hands lets himself be persuaded to share memories and stories from his past in the rough wilderness of northern Montana. A group of inmates—growing every day—gathers around him. As time passes, the tales have an increasingly deep effect on the listeners. They are drawn to different spirit animals, identifying with them and soon dreaming about them at night. Finally, the hierarchy among the prisoners starts to dissolve, and the established gangs—the Crips, the Dragons, the Bloods—disintegrate and morph into new groups with names like Fox, Jackrabbit, and Horned Lark.

The prison management is not in favor of the development and moves Emory Bear Hands to another penitentiary, citing security concerns. But one night, something incredible happens. The inmates receive a letter from Emory: at a certain hour the next time the moon grows full, they are all to think of a bird. And when the clock strikes, the cells and hallways are suddenly full of birds. It's not long before they're all gone. The cells stand empty; the inmates have fled the coop.

Thus summarized, the narrative sounds sillier than it is in reality—in the reality of the story, that is. Reading it, the story sounds, if not natural, then at least wholly plausible.

After all, it's birds we're dealing with.

The bird is the most perfect symbol of flight, and therefore also of freedom. Those who have dreams of flying dream that they're birds, not airplanes.

In his book *Becoming Animal*, American philosopher and cultural ecologist David Abram beautifully describes the bird's flight as embodied intelligence, a complex dance with the wind, a continuous improvisation with an invisible and wildly capricious partner:

It is a brilliance we're ill equipped to notice if we associate smartness only with our own very centralized style of cogitation. When we disparage the intelligence of birds, or the size of their brains, we miss that flight itself is a kind of thinking, a gliding within the mind, a grace we humans rarely attain in our contemplations (although if we're following a falcon with our focus, we sometimes find our thoughts soaring as well).

Birds of course have more than *one* way of flying. The earth is home to approximately ten thousand bird species, and there are, if not ten thousand, then at least a very large number of flight styles. Consider,

on the one hand, the pheasant's noisy takeoff, the hysterical flaps of the wings required for the heavy bird not to crash. Then imagine the effort-less swimming of the common swift in the sea of air, high above. If you were to pit a common swift against a pheasant, any reasonable person would cast her vote with the swift as the better flier. But, in fact, they are both perfectly suited for flying. Each and every bird has the exact shape of wing, musculature, and ratio of wingspan to body weight that fits its needs, on land, in water, or up in the air. Time's slow honing of life through natural selection has made sure of this.

The pheasant mostly walks on the ground and uses its wings as a last resort for fleeing dangers through short flights. The small wings and the rapid, explosive wing strokes are ideal for this purpose. The long, slender wings of the swift would be a death sentence here—they would get tangled in the vegetation and the bird wouldn't even be able to lift from the ground.

The swift, on the other hand, lives on air plankton, insects and other creatures small enough that they're not technically flying but just drift like dust in the sea of air, and therefore it needs to stay airborne for as long as possible, ideally continuously. It could never do that with the small wings and exhausting flight of the pheasant.

With that said, we might be forgiven for focusing on the swift over the pheasant here. What concerns us is the magic of wings as an important part of birds' appeal, and swifts have more of this magic than most.

They eat, drink, and mate while they fly. When a large depression looms in the weather, most birds hide and wait it out, but not swifts. They fly away before the storm hits, skirting it to return when the weather has stabilized again. Such an excursion can span many days and bring the bird across nations—not that the swift would notice. It doesn't know any borders.

Within aerodynamics, the science of flying, two important aspects of bird wings (and airplane wings) are noted. First, the width-length ratio, and here, the unusually thin, sickle-shaped wings of the swift are remarkable. Second, the wing loading, that is, the weight to wingspan ratio. The lower the wing loading, the more effortless and elegant the flight. Picture the flight of the swallow or the tern, or even the kite and certain types of owls. Though the shapes of the wings on these birds vary—with those of both the swallow and the tern being slender and pointed, the kite's evenly wide and slender, and those of the owl more or less broad and rounded—they all have in common an unusually low wing loading. All of them also seem to be playing when they are flying.

The most wing in relation to body weight is found in the imposing frigatebird, which lives in tropical waters across the earth. The type called great frigatebird has a wingspan of ninety-one inches and a body weight of just three pounds. If low wing loading were a competitive sport, it would be the world champion. Like many other seabirds, frigatebirds

spend nearly all their time flying over the oceans looking for food. But their challenge is particular since they, unlike a bird like the albatross, are unable to land on water and therefore must rely fully on their wings during their maritime excursions. Scientists who studied a large group of frigatebirds on their food expeditions found that they stayed airborne for up to forty-eight days in a row.

The swift takes the art of long-distance flying to even greater heights. In 2016 scientists at Lund University were able to prove what many had suspected: after the breeding season, swifts who fly south for the winter are airborne more or less constantly until they return to their breeding territories ten months later. A few of the birds in the study did not land once during this entire time.

It's been long assumed that birds who are able to stay in the air for as long as swifts and frigatebirds realistically must also sleep in the air, at least with one half of their brain at a time. This, too, has finally been confirmed. A German team of scientists succeeded in measuring brain activity in great frigatebirds during their long-haul flights. It turned out that they took short naps at night, sometimes with one half of the brain, sometimes with both hemispheres at once. Each nap lasted about ten seconds, and in total the birds slept no more than roughly forty minutes per night. No wonder that once back on land they took the chance to sleep ten times as much every day.

THE MIGRATION OF BIRDS

The storks travel each fall. Whether they travel to the warm countries or if they rest on the bottom of the ocean with the swallows is still unknown, but they return each year . . .

—CARL LINNAEUS, founder of modern taxonomy, from *Carl Linnaeus's Journey to Skåne*

In late May 2010, four dog-tired colleagues were sitting around the kitchen table at the Ånnsjön birding station in Sweden. It was almost four in the morning and they'd had a long night on the mountain—but who can sleep when the answer you've been searching for so long is almost within reach? Despite a hundred years of birdbanding, there were still birds that bred in Sweden each year but whose winter residences were largely unknown. The great snipe was one such bird, up until this bright early morning.

The previous spring, ten great snipes had been caught and each had been fitted with a light-level geolocator on its leg. The geolocator combines a light logger, clock, and data memory that registers and logs information about when the sun shines, which in turn reveals where in the world it is located. This technology has revolutionized bird research: one gram of gear is enough to show where a migratory bird spends its winters. There is, however, one important condition: the bird must be caught again when it returns the next year, so that the geolocator can be removed and the information downloaded to a computer.

Great snipe males gather—just like capercaillie and black grouse males—at specific sites to vie for the favor of the females, and this night it was confirmed beyond doubt that great snipe males like to return to the same site year after year. The Lund University ornithologists had been able to catch two birds with the logger on their legs, and now the tiny geolocators were on the kitchen table, brooding their information. They connected one of them to a computer, and suddenly the solution to their query was only the click of a button away. A moment of solemn silence—at this point, there was still no person who knew where the great snipe winters. Then they hit Enter and the answer appeared: the Congo.

This was a surprise, given that in Sweden, the bird stays above the tree line, that is, in open country with an alpine climate, and the Congo, at least according to general understanding, is largely rain forest.

But even more remarkable was that the birds had traveled there without landing once, which meant nonstop flights of up to three and a half days. And they had made good time: one great snipe had kept an average speed of fifty-nine miles an hour!

No other being on earth is known to move with such speed across such big distances.

Ever since the first birds attempted their initial wing strokes at some point in their dinosaur pasts, they've finessed the art of flying beyond

what humans can comprehend. Flying doesn't just permit certain types of birds to spend almost all of their lives in the air—it has also opened the world to the birds, giving them lives that span continents and oceans.

Of course, they're not the only creatures to travel across sea and land. Every summer migratory dragonflies, butterflies, fruit flies, and bats journey to new seasonal homes. Even animals without wings can complete annual migrations across huge distances. Gray whales and humpbacks do. The wild reindeers of the tundra do. And the gnus on the savanna do.

But no other animal symbolizes the essence of migration like the bird. No other more clearly illustrates that the earth is one.

The phenomenon has tickled human curiosity for thousands of years. Birdbanding has enabled systematic research on migratory birds for about a hundred years. Bit by bit, the research arsenal has been expanded by even more sophisticated hyper-light electronic equipment, and now even the most difficult birds to study have had their winter residences and migratory routes charted. The great snipe is one of them. The results have often been surprising. A couple of decades ago it was generally accepted that birds could not fly without stopping for more than 2,500 to 3,000 miles. So, it caused quite a stir when it turned out that some bar-tailed godwits regularly fly all the way from their breeding territory in Alaska to their winter residence in New Zealand without stopping. That's a distance of almost 7,000 miles.

The bar-tailed godwit is a shorebird that can't land on the water, and which, in contrast to seabirds like the albatross and the frigatebird, can't stay in gliding flight for long periods of time since it needs to continuously move its wings. Nobody ever considered that such a bird would be able to cross the Pacific Ocean. The thought was laughable, as one of the researchers involved put it in a comment to the discovery.

And the magic doesn't fade, not even after their unsuspected capacity has been proven and documented. From our vantage point as humans the accomplishment seems like a small miracle, and yet it's repeated, year after year, throughout a long life (bar-tailed godwits can live for more than thirty years).

For the bar-tailed godwit, these journeys aren't remarkable. Nonstop flights across the Pacific? That's just what this bird does.

Many of the things migratory birds do—how they know when to leave, how they find their way, how they find the energy—seem like magic to us. Human knowledge about specific details keeps increasing. Scientists have shown that migratory birds get navigational help from the sun and the stars, from landmarks, and from the earth's magnetic fields as they orient themselves. Still, we as external observers will never fully understand that which is completely normal to them.

It's like trying to imagine what it's like to be another person by reading an encyclopedia of human physiology. The text may explain in

great detail the machinations of hearing, vision, sense, taste, and smell; it may map neurons and synapses lighting up in the brain, but you learn nothing about what it's like to actually be this person and how she understands the world.

The feats of migratory birds, just as all birds' various accomplishments, might always be essentially inaccessible to us. Inaccessible, and boundlessly interesting.

Would we even have it any other way? They are birds, we are humans. They have their wings, we have our curiosity.

THE CLOSENESS OF BIRDS

*This is what I intend to try. In particular when I'm grieving: listen
for wrens.*

—KATHLEEN DEAN MOORE from *Wild Comfort*

The air acrobatics of birds, as well as their capacity for long-haul flights,
are incredible. But there's another link between their wings and our
attraction to them that should not be forgotten—an aspect which, though
pedestrian, might play a bigger role than any other to make birds the
closest among our wild friends:

Birds *know* they have wings. Perched somewhere, a bird knows that it
can take off in an instant and reach safety. It is this knowledge that allows
the blue tit and the bullfinch to come feed at our windows. It's how the
western jackdaw is brave enough to settle down for the night in the city
park, in the trees just a few feet above the heads of the evening walkers.

While the majority of wild mammals do their best—and rightfully
so!—to hide from us, most birds dare to live their lives right in front of
our eyes. They let us witness as they squabble and flirt, build nests, feed
their chicks, and learn to fly. We are given the chance to get to know
them without even needing to make an effort; it's enough that we keep
our eyes and ears somewhat open.

Perhaps this is most obvious during the winter months. When every-
thing else seems to have died or gone underground, the common birds

are still there: tits and hooded crows, house sparrows and tree sparrows. Ducks are visible wherever the water is free from ice. But it's really the same in any season: birds, more than others, represent and symbolize that the world is alive. When we look for signs that sun and warmth are returning after the dark season, there are plenty to be had: the anthills begin to swarm, the pussy willow blooms, and the queen bees awaken. Joyfully, we discover the first cowslip and liverwort, and the bright, tiny leaves of the birch tree. But with all of this, it's the birds that most clearly point the way: the song of the skylark, the skein of the geese. The white wagtail suddenly appears, wagging its long tail. The crane honks its horn, and the swallows perform in the sky.

Ah, the swallow! The British naturalist Gilbert White noted the first appearance of the barn swallow thusly in his journal of April 13, 1768: "Hirundo domestica!!!"

A Latin species name and three exclamation marks: no need to say more. We still understand exactly what he meant 250 years later. We feel the same way.

Poets keep writing with enthusiasm about other birds and in other words. W. H. Auden's poem "Short Ode to the Cuckoo" describes his excitement at hearing the first cuckoo of the spring as a "holy moment"—something special despite the almost childish, two-tone simplicity of the bird's call.

Phenology is the term for systematizing observations about seasonal events like the arrival of birds in spring in order to make science from

them. It's a highly interesting discipline in these times of climate change and one where anyone with a notebook and the motivation can pull their weight in the empirical undertaking. But for most of us, the desire to jot down the year's first sighting of a singing skylark probably has nothing to do with science and much more with a wish to capture and hold on to a moment of happiness—a happiness that often goes hand in hand with relief.

Ted Hughes's poem "Swifts" shares deep relief that the "globe's still working" when he sees swifts return another year. His poetry captures the enormous density of meaning and emotion that a pair of tiny bird wings can carry. Things weren't as dark as they seemed, after all. The world still works, despite it all.

Birds might seem a small comfort. But they do bring solace!

While working on a different book, we met Anna who spent a long period in isolation at a hospital while being treated for life-threatening leukemia. She was in pain. She was lonely. Her prognosis was dire, and she was tormented by a fear of death. But she had come prepared, bringing to the hospital everything she could find in the way of nature films and recordings of nature sounds—both those she'd purchased and those she'd made herself. In the darkest moments, when her pain and fear of death were strongest, she would put on a tape or a record that filled the room with birdsong.

It worked! In her mind, she was transported to the forests of her home and found herself more like the person she'd been there— stronger, less ill. She remembered herself as a person who was not full of pain and fear.

She doesn't claim that birdsong was the medicine that saved her life. But it did give her the energy to fight.

British author Iris Murdoch offers a similar, if less dramatic, picture of the healing distraction that birds can provide in *The Sovereignty of Good*:

I am looking out of my window in an anxious and resentful state of mind, oblivious of my surroundings, brooding perhaps on some damage done to my prestige. Then suddenly I observe a hovering kestrel. In a moment everything is altered. The brooding self with its hurt vanity has disappeared. There is nothing now but kestrel.

In the same vein, the winter feeding of birds so fearless that they'll land on your hat and eat from your hand, can cause grief and frustration to dissipate. There's a deep, restful oblivion in the encounter with a being so entirely different from you that no social mores are necessary and also so close that it allows you to feel wholly and unconditionally accepted. In that moment, there's nothing but bird and forest.

In the beginning of this text, we wrote that this is probably not a book about birding. Now that we've come this far, we are even more sure about that, at least as long as "birding" is taken to mean an activity dedicated to the effort of determining the species of a bird, the rarer the better.

Being receptive to birds is both much simpler and much bigger than that. It's not a hobby; rather, it can be seen as a loving receptivity to the larger *we* to which humans are lucky to belong.

Feeling that you're a participant in life on earth is a magnificent experience, but it doesn't necessarily come through grandiose realizations. It might more often arrive in simple encounters with small singularities, like those named robins or waxwings. Or a whale surfacing to exhale, a salmon jumping, a flowering maple tree full of bees, a molting dragonfly—but such encounters are rarer.

Birds are not better, more refined, or nobler representatives for the lives in nature that accompany ours. But for many humans, birds are closer than any others. They are the most obvious link to the large world outside the human bubble.

For *these* reasons, birds!

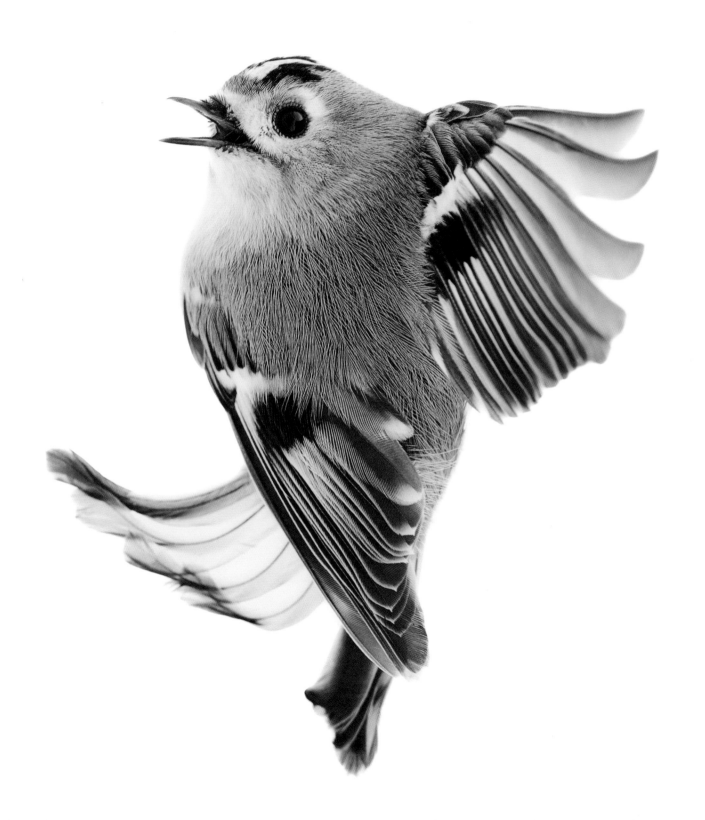

GOLDCREST. In his book *Mom in the Forest,* Björn Berglund writes: "Happiness is being incredibly present, not just in the imagination, but in some real actuality, with the smallest bird. . . . The goldcrest doesn't know it, but he or she contributes to a crusade for the easing of a human need."

For someone who has never experienced this type of happiness, it might seem strange that a goldcrest can spark such big emotions; most things are insignificant about this bird, one of our smallest, not just its size. Its voice is needle-thin. Its coloring resembles the material it uses to build its nest: moss, lichen, and spiderwebs.

But human hearts, of course, are liable to open to small beings. And let's not forget about its demeanor! You can't tell from a distance, which is how you usually spot the goldcrest—by indefatigably scanning the youngest twigs of the branches at the very top of the spruce tree. But if you're lucky enough to get close enough to see the golden cap on its little head, so close that you can look into the bird's eyes, you'll know you have encountered someone with the potential to achieve great things.

Survive, for example.

You might not think that such a tiny pixie could take advantage of any of the strategies—moving south or staying in the cold—available for a bird to survive the northern winters. But goldcrests do both. Some migrate south, and some remain. Both strategies can be life-threatening for such a small bird, but it's precisely because of this that they hedge.

Some winters an unusually large number of the migratory birds die, and the species is saved by those who stay. Other winters the knife of the cold is especially sharp, and the migratory birds fill the holes of their fallen comrades when they return in the spring.

Whether or not a goldcrest survives a winter in the northern hemisphere is a question of appetite. During this season, the bird is like a hyperactive engine with a tiny fuel tank that needs to be constantly replenished in order not to run empty. On really cold days it needs a new piece of food every three seconds. Only by bingeing during every single daylight hour can it increase its weight enough—one and a half grams—to make it through the coming night.

The next morning it's back at five grams and needs to immediately start eating again. Yes, five grams! The tiniest member of the bird fauna does not weigh more. You would need around two thousand goldcrests to match one single mute swan on the scale.

Nevertheless, it bears its Latin name—*Regulus regulus*—without any irony. It is a king.

And when retired Sunday school teacher Måd Östberg decided to get her first tattoo, she had no doubt about what the motif was going to be:

I made a drawing of a goldcrest and went to the tattoo artist and asked: Can you do this?
"Sure thing," he said.

I wanted a tattoo that nobody else has. I chose the goldcrest because it's been my little darling since I was a kid and heard the story of how it got its name. I thought it was so clever!

This is how it happened: the birds had decided that they needed a king, and the one who could fly at the highest altitude would get the crown. The golden eagle was able to go very high, and when it had gone as far as it could go, it called out: "I'm at the top, I'm the king." At that moment, the tiny goldcrest took off from the back of the eagle where it had been hiding and went a little higher yet.

I was only a little girl, but I knew how big a golden eagle was and how small a goldcrest. It was magical that the small one could get the big one. I've carried that story with me ever since. Tiny, tough, and incredibly cute: that's the goldcrest.

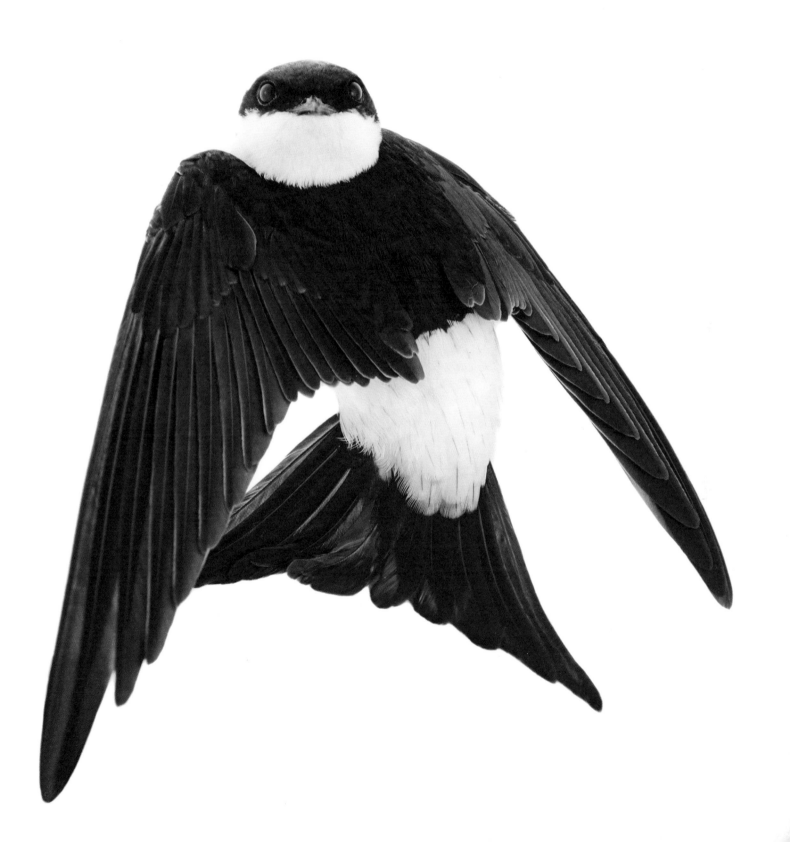

COMMON HOUSE MARTIN. For birds who have an insect-only diet, there's no point in coming north too soon in the spring. But once it's warm enough that the insects have come to life, the house martin—a round, cheerful little flight acrobat—arrives, though rarely before early May.

The martin couple wastes no time in building their masterpiece of a nest. If anything remains from last year's home, they'll construct on top of it. Otherwise, they begin from scratch. Little by little, collecting mouthfuls of mud and layering them on top of each other, they create a closed-bowl form with a small hole for entry at the top. Between 1,000 and 1,500 trips are needed before they complete the nest.

Behind the narrow entrance, the nest is surprisingly large. The entire family usually sleeps inside the nest, even after the four or five chicks have fledged and fly around on their own, as big as their parents. In extreme cases, up to fourteen house martins have been observed to squeeze into the same nest. Several types of martins use this strategy to benefit from each other's body heat when the weather is really bad.

Typically, house martin nests are found at the top of a building, at the meeting point of wall and eave. Indeed, the link between the house martin and our houses is so natural that it's hard to imagine the birds ever living differently.

But, of course, it was not always this way. In the life span of the planet, human infrastructure has only existed for a short period of time.

During most of this species' existence, the birds contended with rock shelves on steep mountainsides. They still do in some places, but today you'll primarily find them on the exterior of buildings. The barn swallow, a relative, has also taken a liking to human structures, but contrary to the house martin, the barn swallow prefers to construct its nests *inside* barns and outhouses.

Similar but distinct: the difference in preference of home is not the only example of house martins and barn swallows splitting the world between each other—they do everything they can to avoid competing.

Birds from the swallow family, to which martins belong as well, catch insects while airborne, just like the common swift. But the two species hunt at different altitudes. The barn swallow is near the ground, the house martin hunts above it (on average at sixty-eight feet), and the common swift at the top. The only exception is during bad weather, when insects fly low and all three are forced to hunt near the ground.

They also have different tastes in choice of prey. The barn swallow goes after comparatively large insects, the house martin takes smaller swarming insects like aphids and gnats, and the common swift catches the smallest ones—those called aeroplankton because they drift, rather than fly, through the air.

The season is coming to an end. The house martin couple might have laid another clutch of eggs. Soon they'll be heading south, perhaps as far as South Africa.

But before they go, these social birds gather in large chattering flocks, as if they were planning their trip together. Their favorite spot is electrical wires and telephone wires. The view of martins on a wire is so archetypal that one can't help but wonder—once again—how on earth they were able to live before telephones and electricity.

And what are the martins to do once the landlines are dismantled? Rose-Marie Kristoffersson, a doctor, was so worried by this question that she decided to take action:

We've always had house martins on our property. From when I was a kid, the electrical wires have been the martins' wires, so I was distraught when the utility company wanted to remove the poles and bury the cables. I called them and talked to a clerk: "You probably think I've lost it, but I'm wondering if you could leave the poles and cables at my house. For the martins," I said. He replied: "Yeah, I think you're a little crazy, but I don't see any reason why we couldn't leave the poles and wires. But then they'll be your own private property."

That's how it went. I posted a note on Facebook about how happy and grateful it made me. After that I could tell the utility company: People love you for what you've done for the martins!

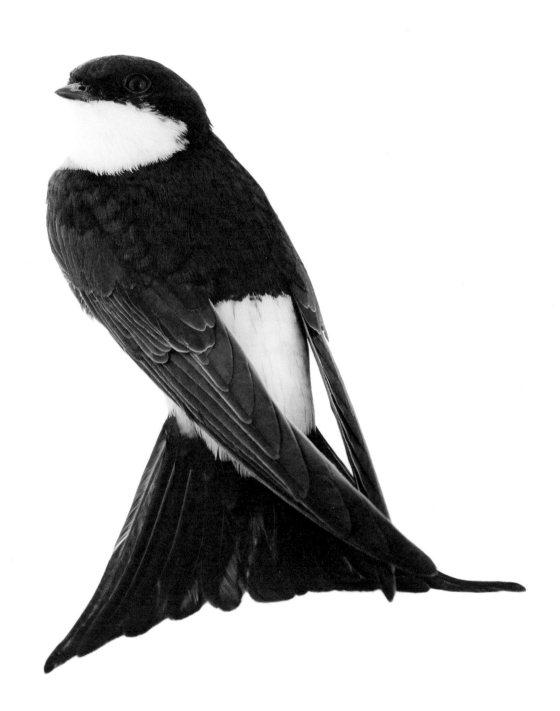

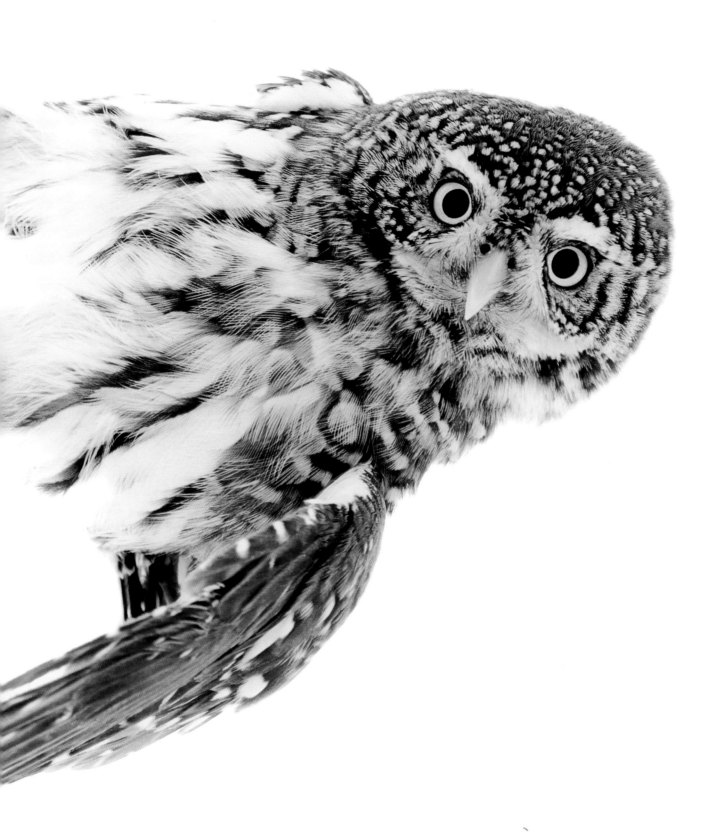

EURASIAN PYGMY OWL. The first encounter tends to be characterized by confusion. Do such small owls even exist? Only as tall as a house sparrow, the pygmy owl is the smallest of the thirteen European owl species.

The minuscule scale has an important role in the tender feelings the pygmy owl inspires in the observer—there's something special about our smallest birds. Add to that its great bravery. If you come across a pygmy owl while out walking or skiing, you can often get really close before scaring it off. The round eyes calmly look into yours—or the owl will simply look straight through you as though you didn't exist, the bird fully focused on scouting for small rodents in the dry grass. It's hard to resist such a trustful attitude.

No, there's no denying the pygmy owl's great charm; not even the stern angle of its eyebrows can change that. But ask the animals it hunts, and they'll find nothing cute about it. A pygmy owl can fit in the palm of a hand and doesn't weigh much more than a small packet of yeast; yet, it's a very capable hunter. It can beat woodpeckers and thrushes, birds far larger and heavier, in the chase. Usually, however, it has its sights set on smaller prey like small birds and—especially in the wintertime—lemmings, mice, and shrews.

Being so small comes with both advantages and disadvantages. The pygmy owl can get to hunting grounds that are inaccessible for larger owls and other birds of prey since it can sneak its way through dense forests. On the other hand, it faces a big challenge every winter. Fast

metabolism is required to keep a small body warm, and the pygmy owl must eat frequently or it will freeze to death.

So, it hoards. In late fall, it begins to neatly layer catch after catch, stomach-side down, in abandoned woodpecker holes or starling nest-boxes. This way it ensures it will always have food, even on days with bad hunting luck. It's not unusual to find twenty lemmings, shrews, and small birds per storage, but sometimes they manage to pile much more than that. The record number observed is two hundred dead animals in one hideaway.

One reason we know so much about the habits of the pygmy owl is probably that they like to mate and hoard in human-made nestboxes. Nestbox birds are always easier to study. It's also likely that the bird's confident demeanor plays a role, making us feel that we're trusted as we're allowed to get near. There are many men (because they usually seem to be men) who dedicate days, weeks, and years to build a relationship with this little one. It's like the pygmy owl is slightly addictive. One of those thus afflicted is former railway technician Leif Carlsson who during multiple periods of his life has spent uncountable hours in close proximity to the pygmy owl, enjoying its company and sating his curiosity:

Few birds allow you to come as close as the pygmy owl. You can spend time with it without feeling like you're in the way. They just do their thing and you can calmly sit down and watch what on earth they are doing: see the female

fussing about in the nestbox and the male arriving with prey. All of a sudden you might see him arrive, towing a thrush chick that is much heavier than him. He hands the prey to the female who carries it the last distance to the nest hole, with some effort. She stands more or less straight up in the air and her wings beat quickly, like an insect's.

And all of this goes on with me sitting nearby. They know I'm right there, but they completely ignore me. Up until the day the chicks leave the nestbox for the first time. At that point I'm no longer welcome, so I leave them alone. The chicks are vulnerable the first few hours and days outside the nest since they don't know how to fly very well yet. If you come too close, the parents protest just like any other bird. You might get a scratch.

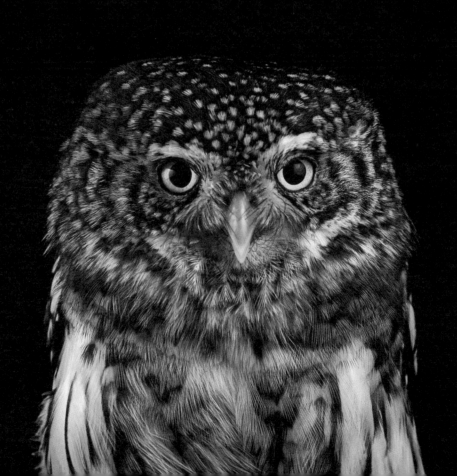

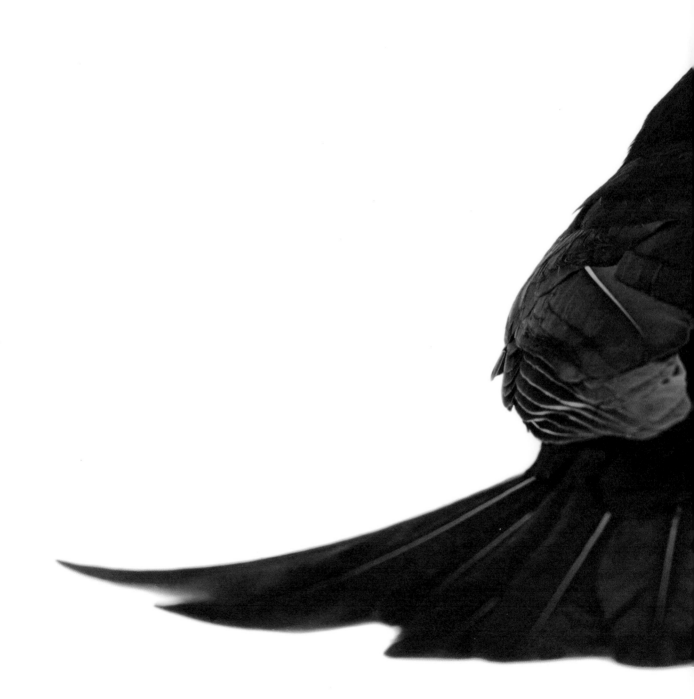

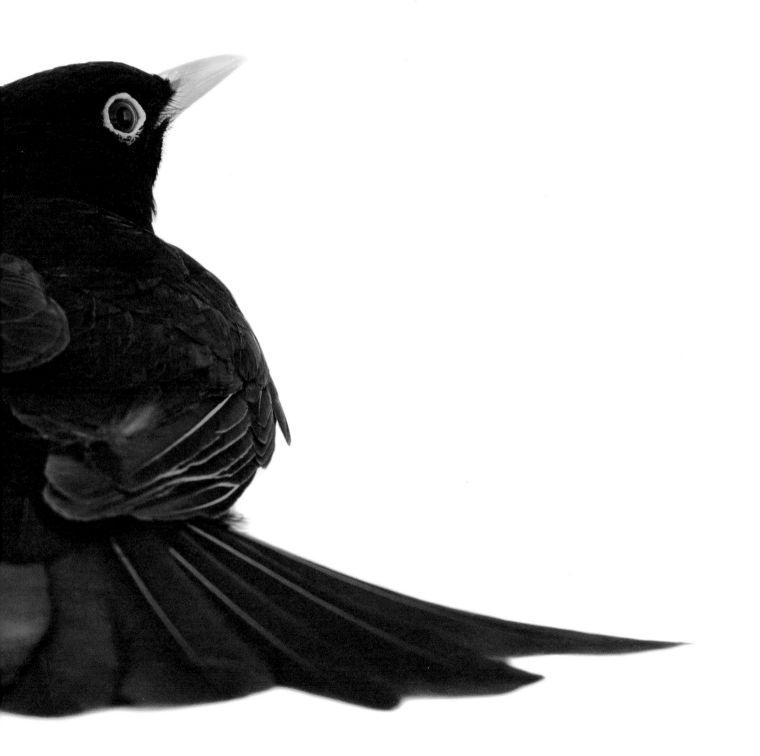

BLACKBIRD. If looks were the only consideration, the blackbird would hardly have been selected—twice, even—as the national bird of Sweden. Granted, the blackbird is handsome, in particular the charcoal black male with his bright yellow beak and ringed eyes. But superficial looks don't pull at the heartstrings enough to explain why something becomes a national treasure.

Song, however, is different.

There's probably no other bird, at least not in this part of the world, that can move as many people through its song. A skillful blackbird makes every phrase a masterpiece. The blackbird has feeling. In one of the most beloved episodes of the radio show *Morning with Nature*, Lasse Willén mixed a singing blackbird with Ray Charles's "Georgia on My Mind." American soul and Swedish soul: a magical duet.

Many find the song of the blackbird melancholy. It's true that it's not as jubilantly joyful as the lark's. But is melancholia not mostly in the ear of the listener? Is it not that little pang one feels in the heart when considering the fleetingness of beauty and life, which is what the blackbird seems to sing about with such precision?

In other words: biology and poetry are rarely as close as when the blackbird sings. In the foreword to the poetry anthology *The Poetry of Birds*, editor Tim Dee recounts sitting on the jury for a major British poetry competition in 2005 and reading every single poem that had been published that year. The most common subject by far was the blackbird.

"Poems about this thrush—many of them good—far outnumbered poems about war in the Middle East or any other apparent urgent topic."

The proximity of humans to the blackbird strongly contributes to its unique position. It was once a mere country bird, but it has expanded its domains and annexed the urban centers. Now we hear blackbirds exploding with mad laughter (yes, that is actually how its warning call sounds) in the underbrush of city parks. We spot blackbirds pecking for worms on the schoolyard lawn.

Even in the wintertime they sit in the barberry bushes that line the town house front lawns, their feathers puffed up so they resemble perfectly round balls. This bird hasn't just turned into a city bird; it's also become a winter bird. One reason is the warmer climate, but it probably helps that thousands of people feed them during the winter.

Art teacher and artist Alicia Sivertsson has done it her whole life: fed blackbirds. And the return has been good:

The blackbird was the first bird I knew the name for. There were lots of birds that we fed in the backyard of my childhood home, but the blackbird won a special place in my heart. One year it built its nest right where we'd eat dinner in the evening.

The female was pals with my mom, but the male in the blackbird family would come to me. It seemed like he recognized me. He'd come meet me

as I was walking down the street on my way home. Sometimes I spotted him from far away in the golden chain tree outside the house. He'd hop ahead of me up the gravel path, angling to have a few raisins thrown at him. It was a nice greeting—like he was saying welcome home.

When I sat on the couch watching TV he would perch on the window ledge on the other side of the glass, looking in. As soon as I got up he'd fly around the corner of the house to get a snack.

I once embroidered a blackbird on a vintage shirt to hide an ugly logo. It took me four or five hours, all night, and I forgot to eat dinner. I was working from a photograph of my old blackbird friend.

It feels comforting having a blackbird across my heart. Like a protective spirit.

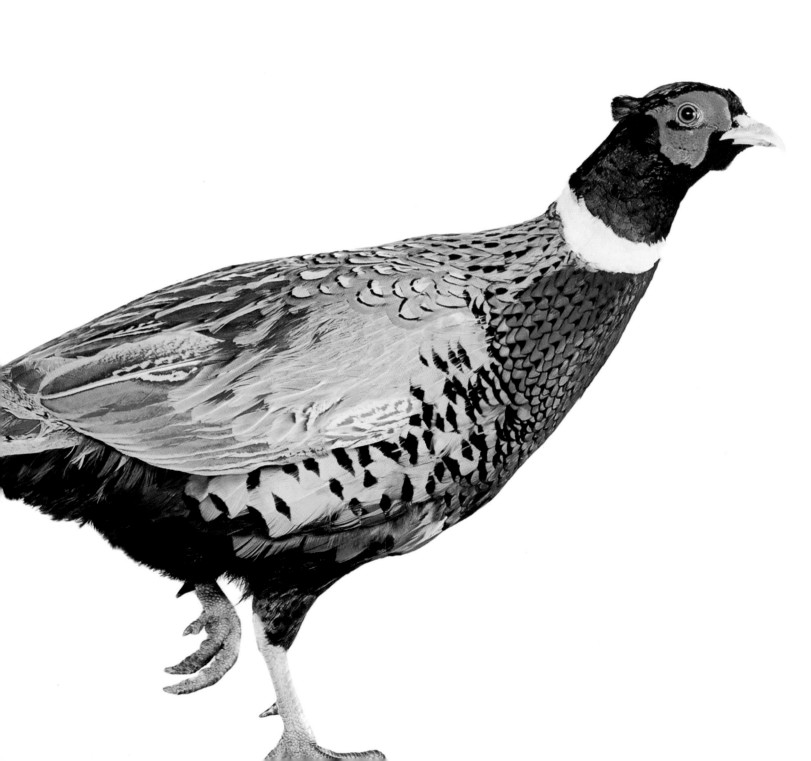

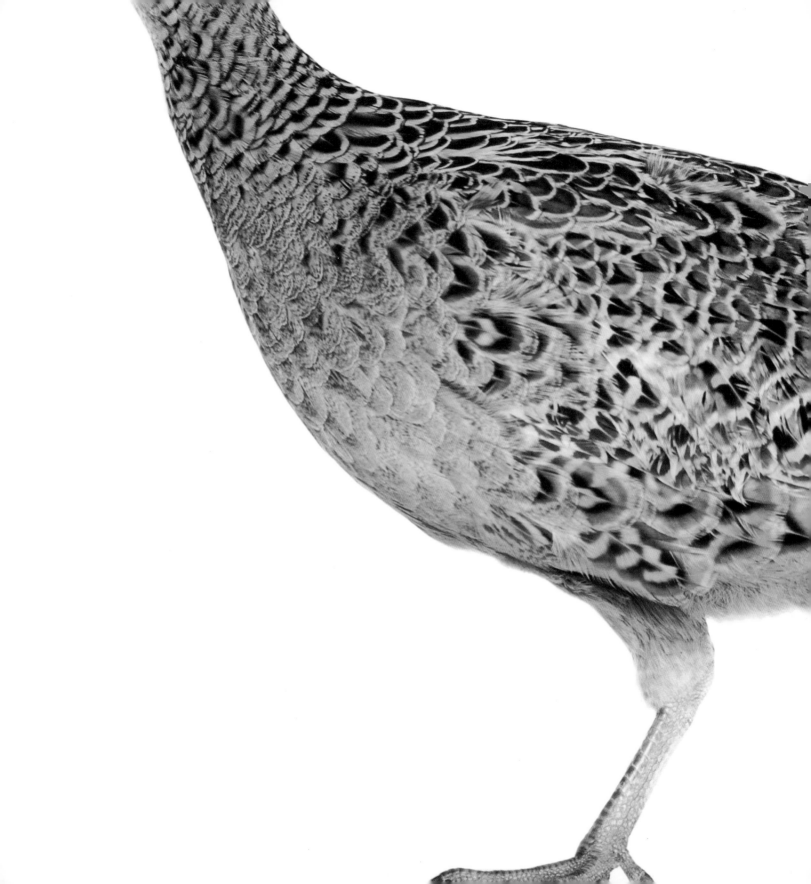

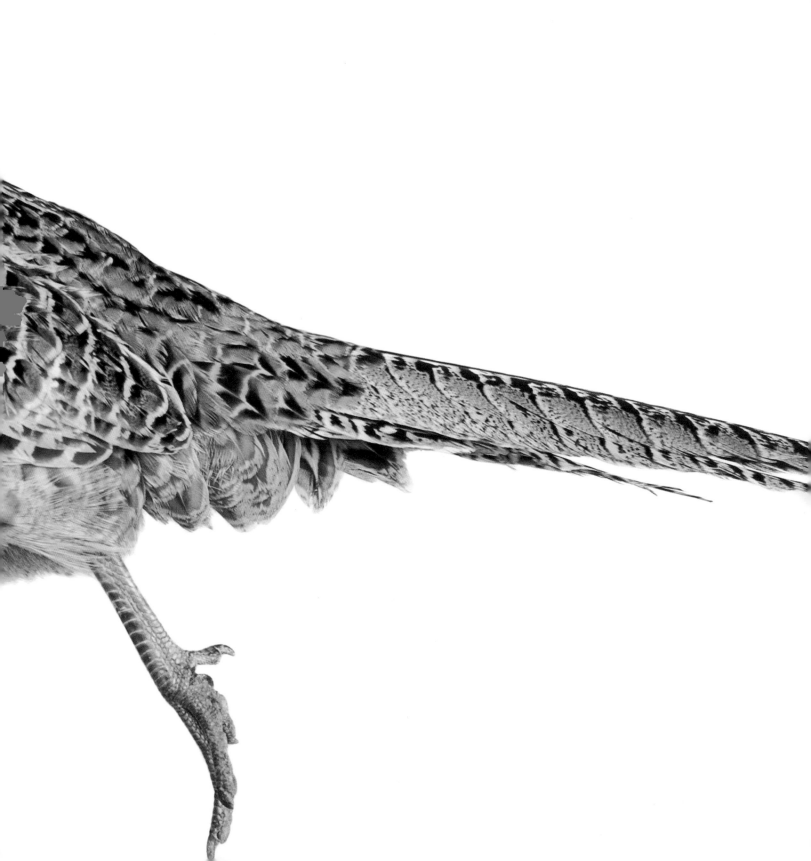

PHEASANT. In October 1952, the witty British ornithologist and professor of languages M. F. M. Meiklejohn had a pheasant-related experience that would've been forgotten today had it not been for the professor's sense of humor.

The pheasant in question, a hen, was found sitting on a nearly submerged rock sixty-five feet from the shore some distance south of Dunbar on the Scottish coast. Suddenly a wave toppled the bird, which fell into the water. After floating on the surface for a few minutes it took off and flew to land. That was all.

"This is probably the only known case of a pheasant doing something interesting," Meiklejohn wrote in the *Edinburgh Bird Bulletin*.

His primary intent was of course to entertain his readers, but the comment is nevertheless illustrative of many ornithologists' view of the pheasant. In fact, it has more to do with that attitude than the pheasant itself.

Scientist Sten Selander wrote in the first part of the twentieth century, "they belong in some bright Orient." He thought pheasants looked artificial, "like mechanical toys for the Emperor of China." In his favor, it should be noted that the roosters are pretty to look at when spring feelings make their cheeks shine red like lacquer. "They can't help how bad they sound when they open their beak. I just think about what my singing sounds like."

The pheasant has been introduced around the world and has put down roots in North America and Europe. But there's no telling whether

the pheasant would stay such a common sight if hunters ceased releasing large numbers of chicks every year. And this might be the core of people's uncharitable attitude toward the species: the bird has been imported, and therefore it is viewed, consciously or unconsciously, as less "natural" than a species that's here by its own powers alone. Catching a glimpse of a pheasant is no event—they've been embedded by the thousands in our landscapes, where they run around like, well, headless chickens, and let themselves be run over on country roads or shot by hobby hunters.

But suddenly a pheasant does something to remind you of the wildness that exists in its heart. A flock of pheasants might find shelter in the cherry tree crowns of your garden in order to escape the prowling predators of the night, just as their wholly wild relatives do at home in Asia. Or someone describes them with words that show you a new side, like artist and ornithologist Lars Jonsson in his book *Winter Birds*. His portrayal of the pheasant rooster courting the hen make the bird seem at least as exciting as the capercaillie.

The male exposes the length of his backside by angling his body toward the female and opening it to create a tapestry of shades and patterns. His tail unfolds like a fan. He keeps getting in the way of the female, as though he wants to force her to take a look at the beauty, like an exceptionally stubborn carpet vendor. In early spring the female seems quite indifferent to the courting

and just keeps eating, but I suppose that as time goes, she begins to find him fairly attractive despite it all.

The bird's origins, then, are in Asia, where the pheasant exists in an array of comparable editions from the Caucasus in the west to Korea and Taiwan in the east. Centuries of breeding and planting of the birds have led to widespread intermingling of the genes, but you can still find roosters in Europe whose feather makeup reflects the bird's roots in a particular region of Asia. For example, roosters with a white neck ring are thought to come from China, and roosters without are believed to be from the Caucasus.

Wherever they came from, they're here now. And home caretaker Ulf Kvarnhalm feels that those immune to their charm are missing out:

Pheasants sound like old Volvos with broken starters, and sometimes their behavior is a little silly, but I think they are wonderful: exotic and different. There are ornithologists who speak badly about the pheasant, but I think that's mean. They deserve to have their reputation rectified!

I've always had a relation to pheasants. You saw them all the time where I grew up. My dad often went hunting with our English setter Maja, mainly for birds, and that of course included the pheasant. I remember eating the bird, served with potatoes, sauce, and jelly. I didn't feel bad for it then, it just seemed normal. But the whole house smelled like all hell when the birds were plucked and the downs burned off.

In my childhood bedroom I had a wall full of pictures of dogs and beautiful pheasant feathers that I put up with pins, including a pheasant tail that my dad had given me. Mom inspected it carefully; she worried it would have fleas.

These days, I like to amuse myself by looking at pheasants whenever I can. We have a single male who comes to the bird feeder at our summerhouse. It makes me happy—it even makes me laugh—to see it. And that sound!

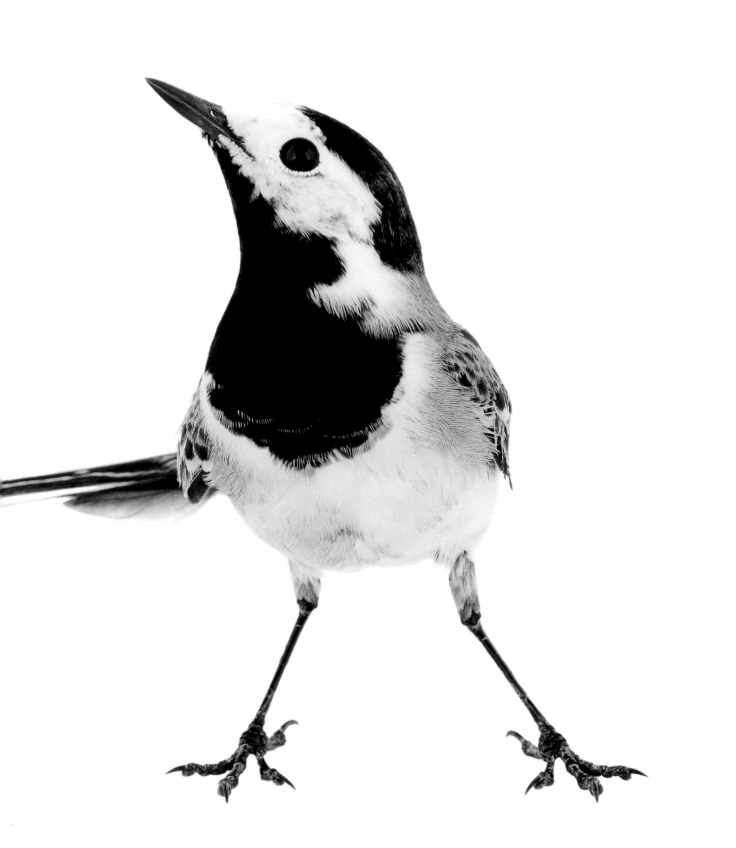

WHITE WAGTAIL. In the war year of 1941, scientist Sten Selander wrote about the comforting joy that the clear blue weather of spring brings despite it all, and he chose to focus on the white wagtail. It comes "with chirps like a quick April shower" after having flown across mute darkened cities, prison camps and concrete fortresses, past uniformed troops and starvation.

The first white wagtail of the year brings out emotion, and it moves far more hearts than those of the relatively small circle of people who identify as birders. If you were to crown the bird that most clearly symbolizes the arrival of spring in Europe and Asia, there's no doubt the white wagtail would be a finalist.

There are many reasons for this.

First, the white wagtail arrives in the north early in the year when we're still starved for signs of spring—it tends to show up as early as the end of March or in the first two weeks of April.

Second, the species is clearly recognizable. No other bird has the same coloring and none other bobs its tail in such a pleasant way. People who live in white wagtail territory recognize the bird and know its name.

Third, it tends to be punctual. At least in the past it was possible to say almost exactly what day the bird would show up. Lately, it seems that the wagtail has changed its schedule ever so slightly. They've begun to arrive earlier in the year, very likely because of the warming climate. Still,

the species has a clearly defined routine, and even if its calendar shifts a bit, it will likely keep being punctual. The white wagtail's regular spring habits come from its inability to adapt its migration based on weather, as migratory birds going shorter distances, for example northern lapwings and Eurasian skylarks, are able to do. A white wagtail that spent its winter in Egypt or Israel has no way of knowing what the weather is like in Scandinavia when it starts heading north. All it can do is rely on its inner clock, the signal to take off set by the experience of previous generations.

Fourth, the white wagtail likes to stay close to humans. While it doesn't need to have people around—desolate mountain lakes and isolated rock formations in the archipelago satisfy its desire for open space to hunt insects—you can't deny our usefulness in creating biotopes that suit the white wagtail: farmlands, green spaces, bike paths, and parking lots. Ergo: the white wagtail is often where we are.

Yet another reason for our love of this bird might be unconscious memories passed down from our history as farmers. There are several indications that the interest in white wagtails was even more pronounced in agrarian society. The bird's arrival in the north was synced with spring sowing, and it was often spotted in the fields. This in turn closely linked the bird to various notions, documented in the old farmer's almanac, about impending good or bad times. If you spotted spring's first white wagtail on a roof, it was said that the harvest would be plentiful, and if

you found her sitting on the ground, it would be poor. Another super-stition about the first white wagtail was that the bird was a harbinger of grief if you saw it from the front (where the black chest marking was visible) and joy if you saw it from behind.

It's a little unfortunate to turn something as lovely as the white wag-tail into a presumptive omen. So much nicer to do as retired teacher Kerstin Söderström:

When I see spring's first white wagtail, I curtsy three times. My mom always did and has done so since the beginning of time. A couple of years ago I was on a walk with five girlfriends when I saw the first white wagtail of the season. Of course I curtsied. This year they were all out on a walk without me, when wagtail number one showed up. They all curtsied, even though I wasn't there!

A girlfriend told me that she'd been raised by her aunts to do as I do. And one of my cousins said her mom taught her to curtsy three times, spit three times, and then wish for something. She lives in the city and says that people probably think she's a little odd, but they can think what they want. It would be interesting to know how widespread the curtsying is. I at least continue the tradition. It's become my way of welcoming spring.

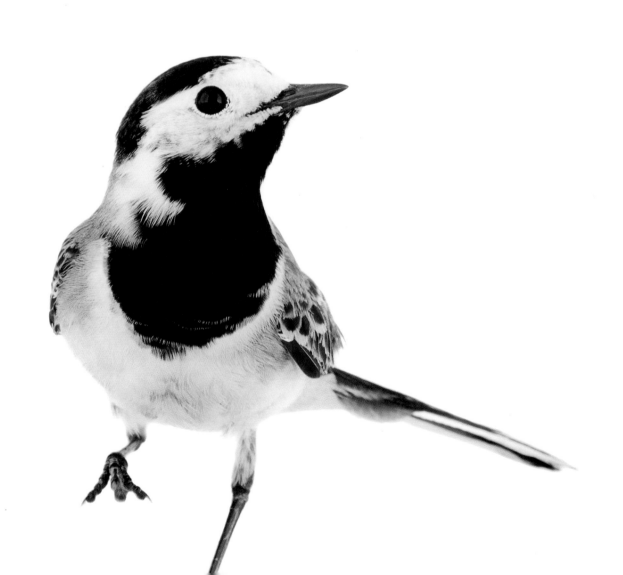

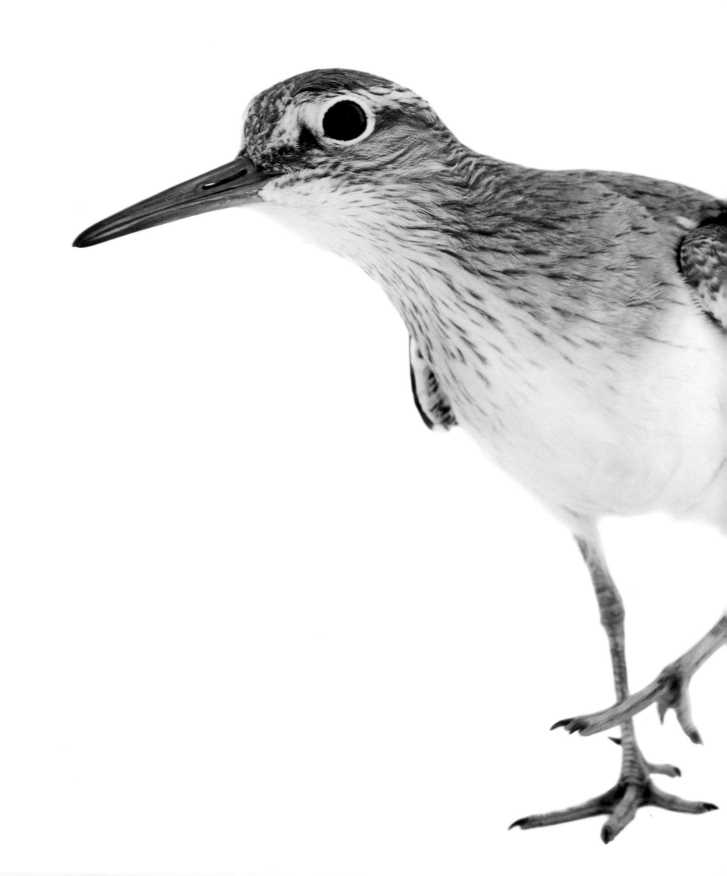

COMMON SANDPIPER. A small shorebird, its posture crouching and slightly front-loaded. Legs shorter than most of its relations. That's what you see if you look at a common sandpiper from a respectful distance. And that gentle rocking back and forth, as though a tiny person stood on its tail, using the bird as a trampoline.

In this case, respectful distance means at least eighty-eight feet. At least that's on average how close they'll let humans come before they take off and fly away, according to a British study on the sensitivity of the species to disruptions from hobby fishers.

The flight of the common sandpiper is at least as characteristic of the species as is the rocking of its tail. They always take off close to the surface of the water—rarely do you see a common sandpiper fly over land. Series of fast, shallow wing strokes alternate with gliding flight on stiff, down-turned wings, so low that the bird nearly scratches the water surface with its wingtips.

The sandpiper is a common shorebird, and it has its particular preferred environments. Many of its relatives are keen on shallow beaches surrounded by open wet meadows, but the common sandpiper prefers the stone-and-gravel beaches of the nutrient-poor oligotrophic lakes in woodlands. It's also near these waters you might be lucky enough to catch sight of or hear the black-throated loon. And once you've learned to recognize the sandpiper's bright mating calls, they'll sound just as typical, if not quite as filmic, to such places as the calls of the loon.

Forest riverbanks are also popular with sandpipers. In early spring you might find the bird standing there, creating a similar atmosphere of comfort with its rocking as the white wagtail does with its bobbing tail.

As tends to be the case with waders, the female common sandpiper lays four eggs. Rarely fewer and almost never more. The eggs are cone-shaped and fit the simple nest on the ground near the water perfectly, like four pieces of a pie.

They are surprisingly large, similar to the eggs of the western jackdaw. Each egg is a fourth of the body weight of the bird herself, and she lays them with a day or two in between. In other words, in terms of mass, she manages to lay her own weight in eggs!

Waders lay big eggs in order for the chicks to grow fairly big before they hatch. The chicks of many other bird species, whose nests are better protected, are entirely helpless during their initial time in the nest, but the chicks of the common sandpiper are able to run around and get food from day one. But they can't maintain their body temperature on their own. If they're out procuring food when it's cold out, their body temperature can drop from 104 to 86 degrees Fahrenheit. When this happens, they have to hurry home to cuddle up under the wings of one of their parents and warm up.

The chicks also rely on their parents' experienced eye to spot dangers. When a predator comes close, whether on two legs, four legs, or wings, the grown birds warn their chicks, who freeze their movement. Their

effective camouflage makes them surprisingly difficult to detect. But life remains full of risks for the common sandpiper chick, and it's no less dangerous to learn to fly and make the long migration to their winter territory in West Africa. Just a little over a fifth of all chicks who hatch in one season survive their first year of life and are lucky enough to return to their childhood homes to mate during the seasons to come.

But those who do return are so much more anticipated by each and every one who, like artist Erik Marcusson, has come to associate them with forest lakes and other waters:

The common sandpiper has the key to my summer heart. I often see her by the lakes where I have my favorite spots. I like to hide among the blooming bog myrtle and look at the sandpipers when they've just arrived. They are like ballet dancers treading an invisible water line, so unusual with their vibrating, down-turned wings in the dance of love. Their trills fill the early summer evening.

I've never been able to find a nest, even when trying, but it doesn't matter. I don't wish to interrupt.

Common sandpipers can be difficult to track down, but their rocking and the peeping sound reveal them standing on the shore, almost blending in with the stones.

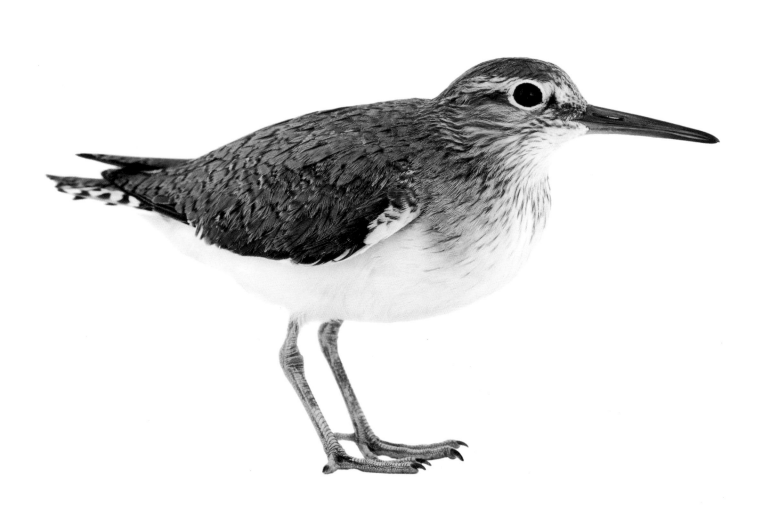

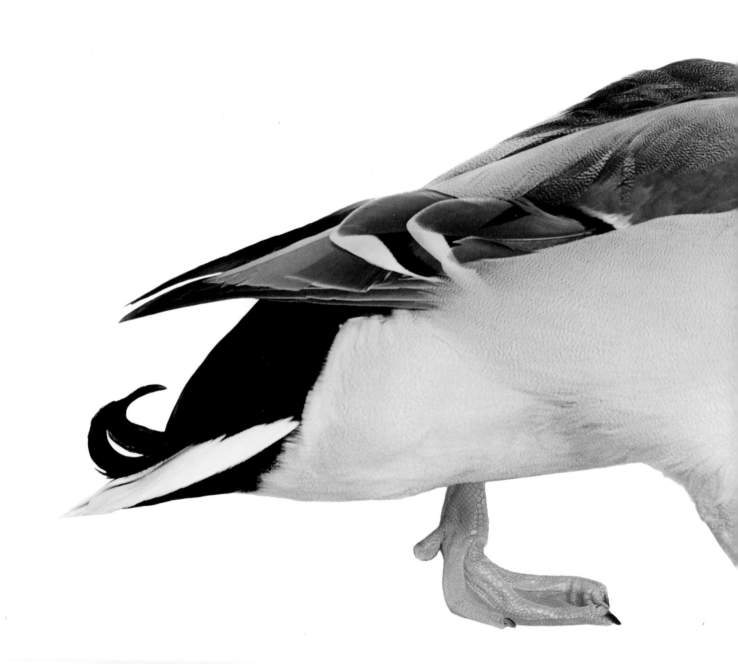

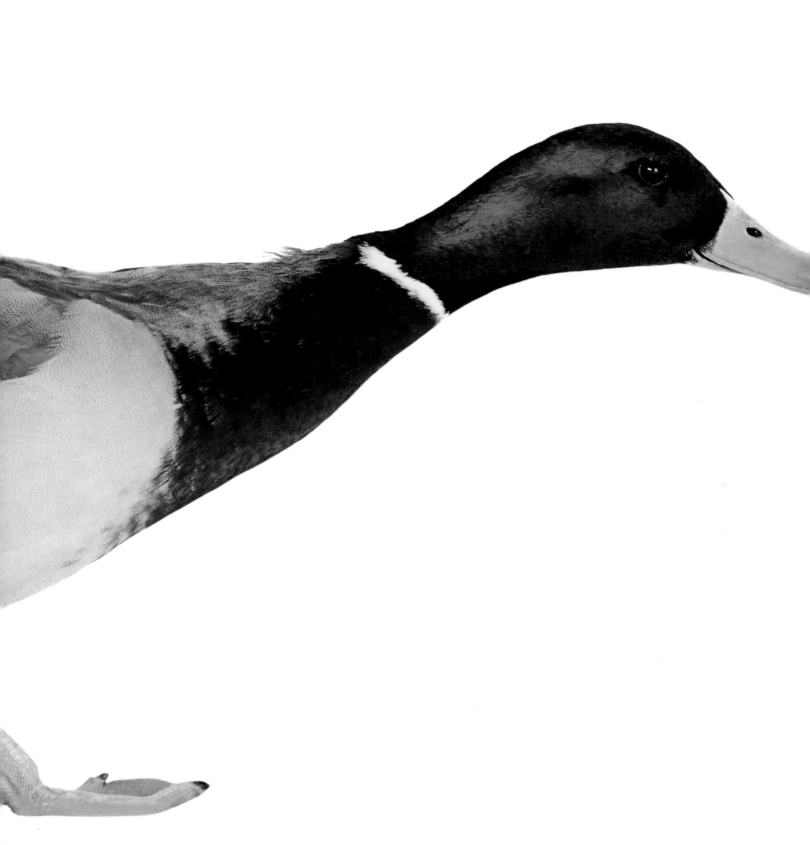

MALLARD. Those of us who live in the countryside know it as a timid wilderness bird that takes off and flees before you can get close. That is one face of this common duck. But most of us know the mallard as a human-friendly bird, one that's gotten used to seeing *Homo sapiens* as a fairly harmless feature of the cityscape and—when it's lucky—a feeder.

If these birds have become blasé about human presence, we might also have become numb to theirs. But all you need to do is look at— really *see*—the green color on the mallard's head, for habit's blinding veil to lift.

That color is no less than a magic trick of optics.

If you take something green and cut it into small pieces, it usually stays green. Like a green bell pepper chopped in a blender, for example.

But this is not the case with the metallic green of the male mallard's feathers. If you'd grab a handful of those feathers and blend them, the green color would no longer exist.

Indeed, strictly speaking it never did.

In contrast to the bell pepper, the feathers of the mallard don't contain any green pigments at all. They have brown pigments in them, but no green. All that exists is a very particular structure: an arrangement of closely and regularly packed stacks of melanosomes so small that they can only be detected in an electron microscope. As sunlight fractures through this nanostructure, the green color lights up (and completely overtakes the brown).

And that's not the end of it. If the angle of the light changes, the feathers that were green just a second ago can suddenly look blue or even purple. It's all in the play of light in the feathers' structure.

There's nothing new about these physics. The phenomenon is called iridescence and can be found elsewhere in nature. It's also exhibited in the tail of the peacock, the emerald and sapphire colors of the kingfisher, the wing covers of the earth-boring dung beetles, and the mother-of-pearl of the mussel shell. Still, there's a miraculous aspect to it—color without color!

And it is regularly right in front of our eyes, in the seemingly most banal of birds at the pond.

But, of course, not everyone thinks about optical physics as soon as they spot a mallard. The need to reclaim this bird's reputation might not even be as pressing as the above argument indicates: maybe it's only the most devoted birders who have a hard time maintaining their enthusiasm. Outside of this circle, many are not at all beset by the numbing effects of the habitual. Truck driver Christian Myrén is one example:

You can get close to the mallard and really make a connection. It's like they get to know you, they start to come running when you bring food. It's wonderful.

I have an interest in birding and photography. When I want to see birds up close, I go to the pond, where I take a seat on a boulder, feed the mallards

with birdseed and boiled rice, and take photos. They're so pretty, I love them. It's very relaxing to sit there. A few birds, especially one female, tend to eat straight from my hand. Sometimes schoolkids stop and take pictures of me and the ducks with their phones. People look at you kind of funny when you're a 33-year-old who likes to go and feed the ducks. But I don't care.

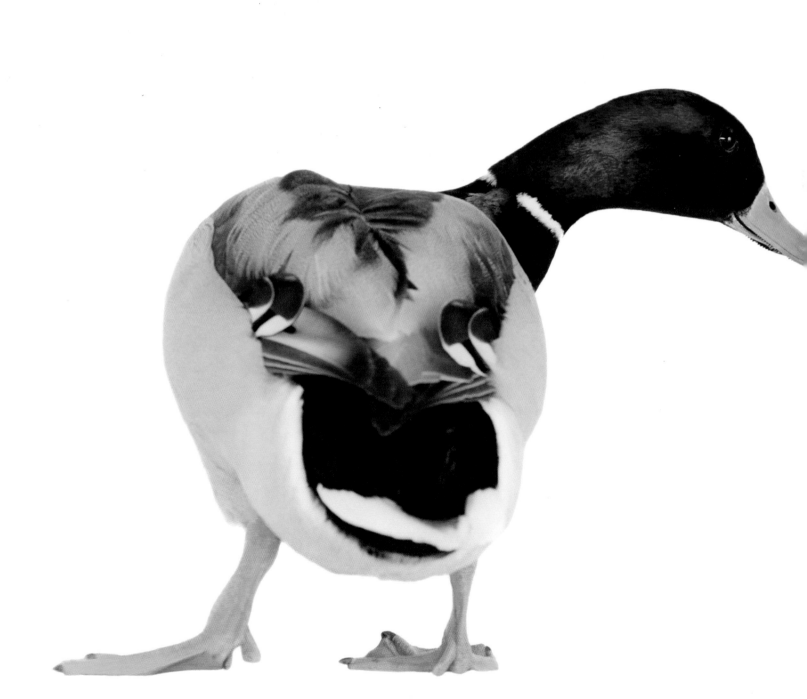

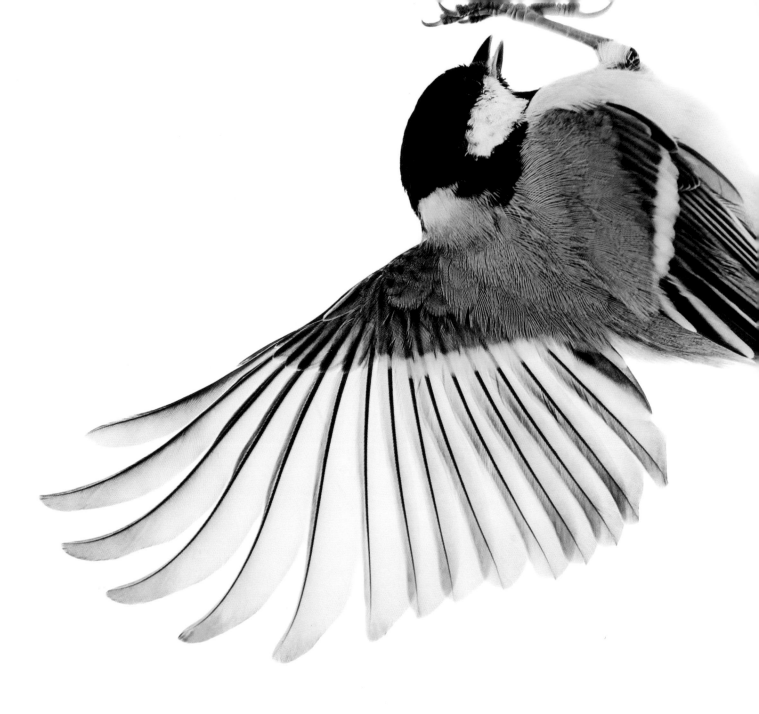

GREAT TIT. Both popular wisdom and scientific research indicate that the great tit is an extraordinary bird. We might even call it the northern raven of small birds, because despite its limited size it can hold a candle to the big, black passerine when it comes to versatility and cleverness.

Just consider the great tit's ability to combine single sounds—there are at least ten varieties in their repertoire—into patterns with different meanings. One sequence of sounds might say: *Come over and look out for dangers on the ground!* The same sounds combined differently would bring about no reaction. The Japanese scientist behind this discovery, Toshitaka Suzuki, was so impressed by the communication of the great tit that he described it with the linguistic term syntax, which is nearly exclusively used to describe the human capacity to combine single words into phrases and sentences.

It took Suzuki ten years of intensive listening and experimentation before he reached a baseline of understanding of the bird, so it's clear that the common person will find it difficult to get any insight into their communication. Other aspects of the great tit's unusually sharp intellect are easier to see. Many of us, for example, are reminded each winter that it's time to refill the bird feeder by a great tit's somewhat entitled pecking at the windowpane. It appears to be the only species that does this.

And that's merely one example of the great tit's creativity in procuring food. Studies at Lund University have shown that great tits—who are

themselves not prone to hoarding food—like to spy on willow tits and marsh tits who do to later steal their stowed-away provisions.

The most well-known example of their ingenuity might be their habit of opening the seal on the milk bottles that are delivered to homes in the early mornings in some countries. The tits' industriousness in helping themselves to cream and milk has been observed across Europe. It's gotten the most attention in England, where it was noted for the first time in 1921. British ornithologists and the milk-drinking general public were able to track the habit spreading across a growing area, as the technique was passed on from bird to bird. Both blue tits and great tits (and in some cases other types of birds) were seen bending paper caps and plucking at metallic foil lids. It's not a far-fetched guess to say that the great tit invented the trick, and that other species took the cue from them. The blue tit is no dummy either, but it is slightly more cautious than its bigger relative.

In more recent years, experiments have confirmed what these anecdotes had indirectly hinted: great tits are adept at learning new habits from each other, so much so that new cultures and traditions emerge among them. Indeed, scientists find reason to apply still more words that are normally reserved for humans to great tits.

Another practice among great tits is to perch on the bottom board of hibernating beehives and knock on the hive with their beak. Groggy bees crawl out to see what the fuss is about—and turn into great tit food.

Even more noteworthy are the reports from Hungary about great tits flying into caves to eat hibernating bats—if not the whole animal, then at least their brains (which are fatty and therefore especially valuable). Or the eyewitness reports from scores of Swedish bird-watchers who were on the island of Öland in 2016, enjoying an unusually large influx of rare birds. The same winds that had swept in the rarities from the east also brought many great tits, who were starved when they arrived on Öland after the long passage across the Baltic Sea. Desperate times call for desperate measures: the tits helped themselves to whatever nourishment they could find, including other small birds.

It wasn't the first time this behavior had been observed, nor is it particular to a bunch of mean great tits from the east. There are stories of other instances where great tits, finding themselves in extreme situations, have turned into shockingly efficient hunters. But of course, if you intend to maul attractive rarities with a bunch of horrified bird-watchers as your witnesses (a rare dusky warbler was one of the victims in the fall of 2016), you won't be able to avoid the attention.

Media coverage of the event showed that many onlookers were astonished that great tits could be predators. It was as though they'd betrayed the desire that many have for small birds to be cute and inoffensive. But the great tit has only one obligation to itself and its future offspring: survival. So, it would make more sense to admire the fact that a bird weighing not more than twenty grams is adaptive and

inventive enough to survive in so many different ways—from devouring other small birds to grooming humans to serve food at their beck and call. Retired metalsmith Anders Morge recounts his story:

My great tit knocked on the kitchen window one morning in early spring of 1980, as I was preparing lunch for the day. I didn't see it at first, so it knocked again. I got a suitably sized piece of cheese and went out to the porch where I meant to leave it on the railing. But the bird landed on my hand, took the piece of cheese, was still for a few seconds as it looked deep into my eyes, and then it flew away. After that he gave me no peace. As soon as I came home from work and got off my bike, the tit came. It would land on my handlebars and asked for food. His wife came as well, and sometimes they brought their kids. Holding the little ones in my hand was incredible!

For thirty years the great tits used the same winning concept with us. I guess the offspring must have learned from the parents' clever applications for food.

These days my relationship to them is a bit more distant. We're still familiar, but I no longer let them eat out of my hand. It's not good when wild animals depend so much on you. In the end we couldn't even go on vacation.

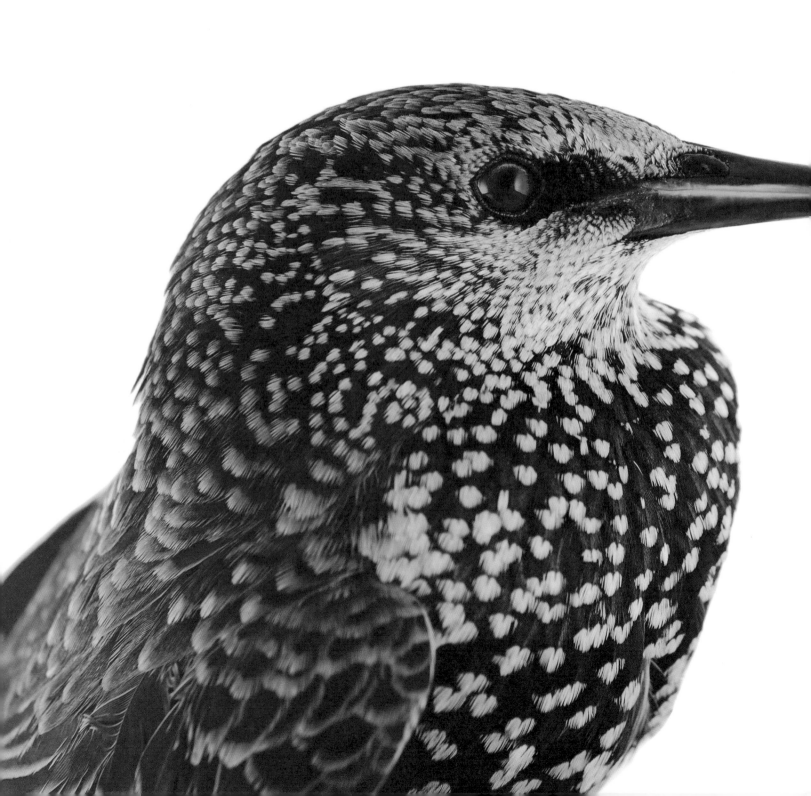

COMMON STARLING. It all began with a few innocent lines in Shakespeare's play from the late sixteenth century, *Henry IV*. The troublemaker Sir Harry Hotspur fantasizes about driving the king mad by gifting him a domesticated common starling that's been trained to say the name Mortimer over and over. It's the name of Hotspur's brother-in-law and one of the king's most hated enemies.

I'll have a starling shall be taught to speak
Nothing but "Mortimer" and give it him
To keep his anger still in motion

That could have been the end of it, had not Eugene Schieffelin of the Bronx had a bizarre idea three hundred years later: Schieffelin wanted to introduce every type of bird mentioned in Shakespeare's plays, a little more than sixty of them, into the United States.

Schieffelin wasn't the only person interested in bringing European plants and animals to the United States in order to make the country a little more like home for its immigrants. The majority of these attempts failed, but the common starling did well. A bit too well. In 1890, Schieffelin released sixty British-born common starlings in New York's Central Park. An additional forty joined them the following year, and soon these birds began to breed baby starlings. By 1928, their offspring had made it as far as Mississippi, and fourteen years later, they were in

California. None of the attempts to stop them were successful, not the more strange initiatives (throwing itching powder at them or cooking them in pies) or the diabolical ones (poisoning them with radioactive Cobalt-60). Today it is believed that the United States is home to more than two hundred million European common starlings, and their enormous and closely constituted fall and winter flocks are about as popular as the Egyptian grasshoppers were in the time of Moses.

On the other side of the Atlantic, in Northern Europe, attitudes are different. Hopeful gardeners construct starling bird boxes. The singing of spring's first common starling is celebrated with joy, and the steady dwindling of the birds' numbers over the last couple of decades is met with sadness and concern.

Here, not even the gathering of starlings in big flocks during the fall inspires negative emotions. On the contrary, such assemblies are considered worth traveling to see. This is true not least in a number of wetlands in Denmark, where the flocks are so large that they're called *sort sol*—black sun—since they darken the skies. At Tøndermarsken, they sometimes number a million individuals. When the common starlings get ready to spend the night in the wide marshlands, the extremely dense flocks behave like living organisms the size of heaven: constantly shape-shifting, billowing bodies that dance with the night sky as their background—uniting, splitting, uniting once again.

There is no leader in this dance. Or rather, every bird leads, and every bird follows. A group of theoretical physicists have calculated that the

movements of each bird affect the closest seven neighbors in the flock and on and on in lightning-fast chain reactions.

No more complex mechanism than this is needed to create an unforgettable performance.

What about Mortimer? Can a common starling really learn to speak?

Yes, actually. It comes from the wild bird's tendency to embellish its song with imitations of other bird sounds. If you suddenly hear the trilling of a Eurasian curlew or the meow of a common buzzard from your roof, the guilty party might just as well be the common starling. And it doesn't really distinguish between the origins of sounds—it's happy to pick up man-made noises like the ringing of a cell phone, the beeping of a truck backing up, or the blaring of a car alarm. The common starling is also able to imitate human speech, especially when given some methodical training.

Yes, they are capable of incredible feats, these birds.

But none of this is needed to motivate a long-standing and close relationship. It's enough to have a starling nearby, a bird that lives as starlings do: arriving in spring, singing, constructing a nest, laying eggs. As long as you have the chance to observe them in peace, as filmmaker Mikael Kristersson likes to do:

I always take it as a spring sign when the common starlings return to their mating grounds. We have several couples in our backyard. They're quiet for

a while, until suddenly there are blue eggshells all over the yard and you see them feeding their newly hatched chicks. The common starlings that live near us are very fearless; they seem to lead their daily life without any anxiety, right next to ours. I've shown it in my film The Inner Life of the Common Starling. One scene shows a male starling plucking a daisy to use it for decorating his nest inside the birdhouse. I've seen males use birch catkins, pieces of tinfoil, and pheasant feathers to decorate before. Maybe he wanted to impress the female?

I happened to be filming right as the male took the daisy from the grass. I realized he was on his way to the birdhouse and had to jump and shout a little to distract it as I moved the camera and set the focus on the hole. The bird flew up and landed just when I started the camera. Then it turned its head and looked back with the flower in its beak before flying in. So exhilarating!

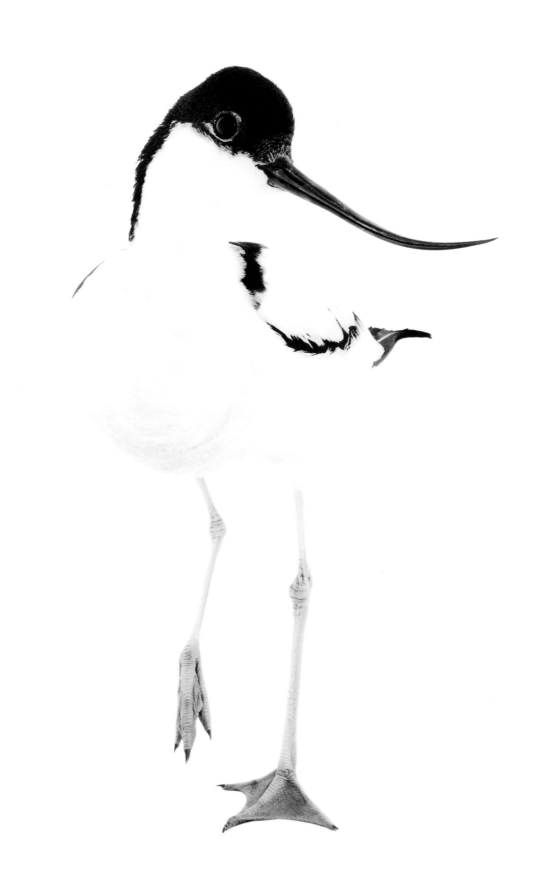

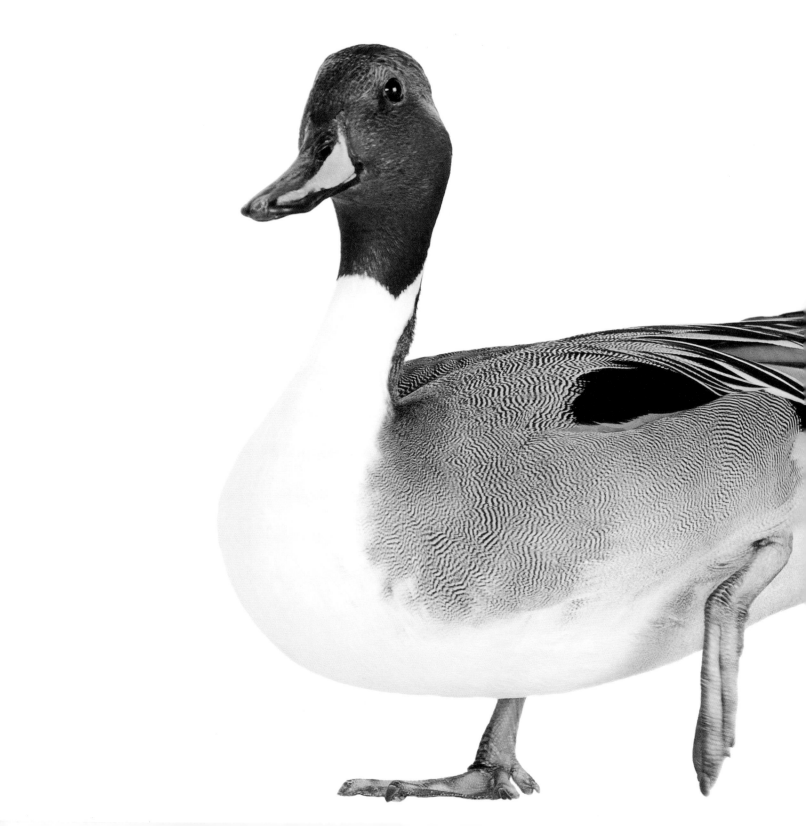

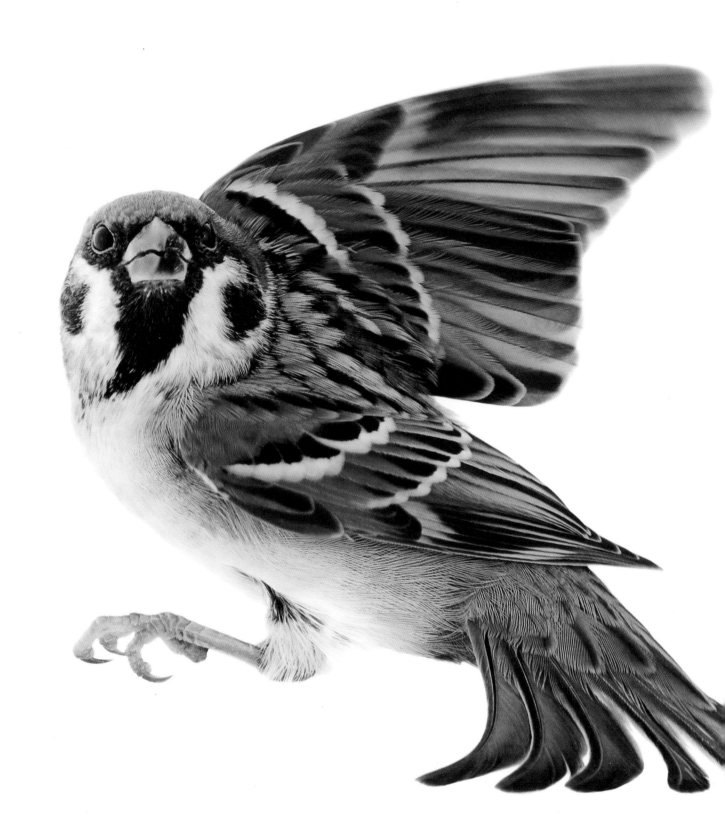

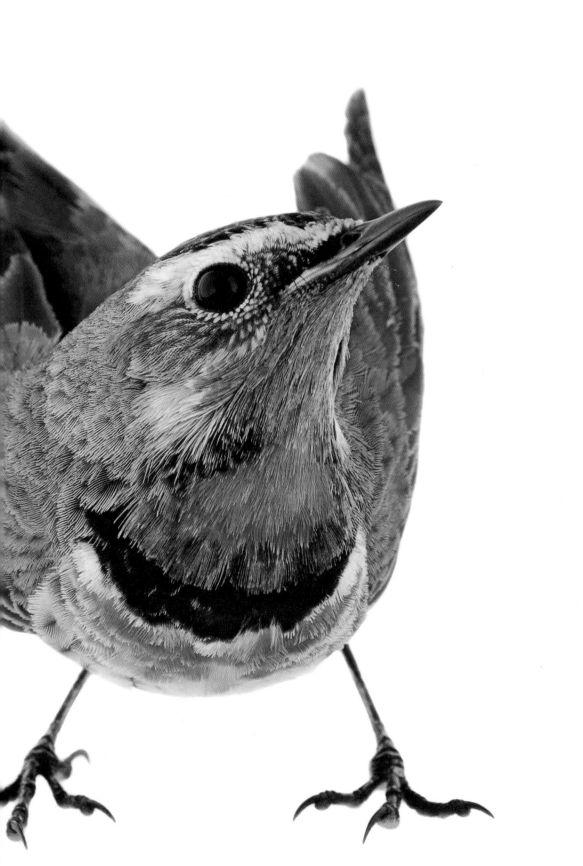

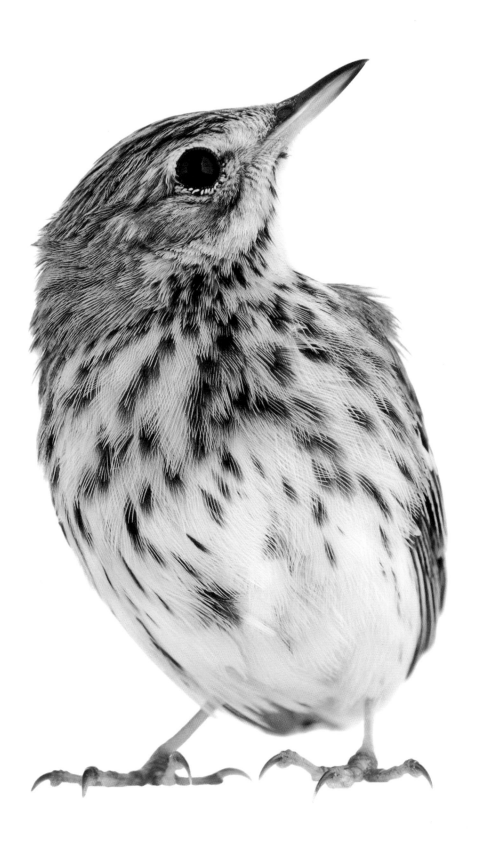

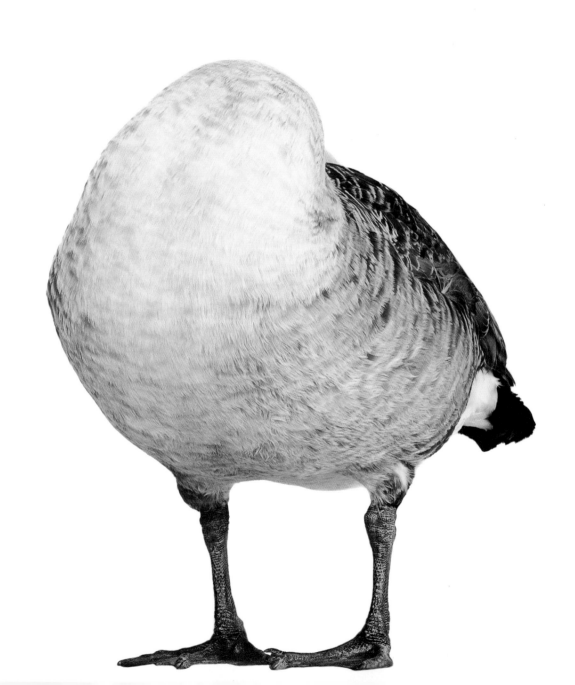

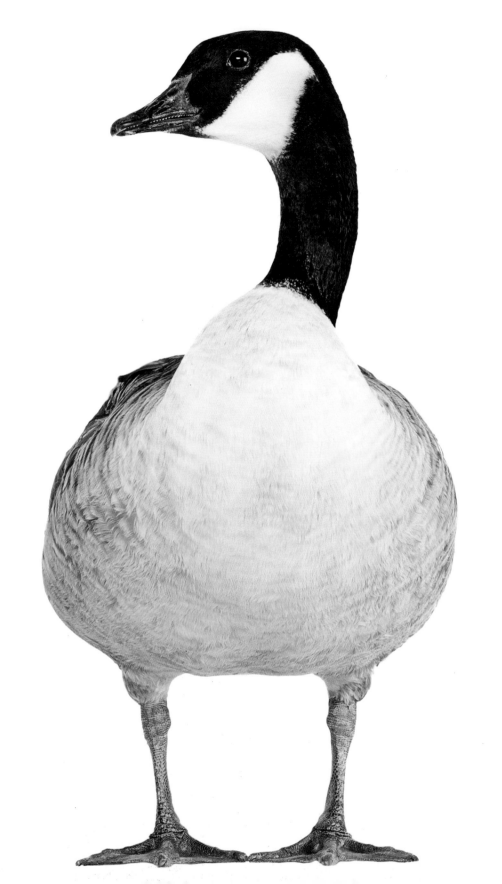

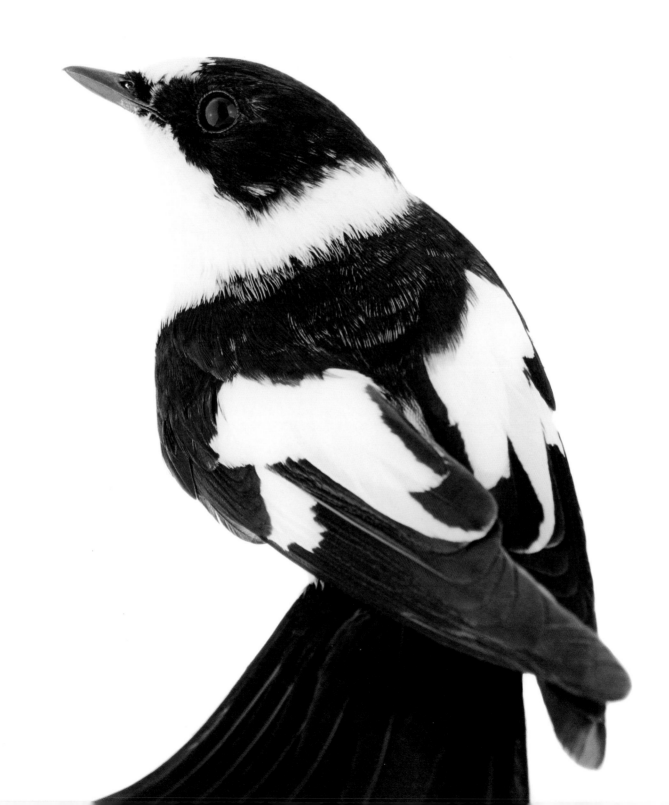

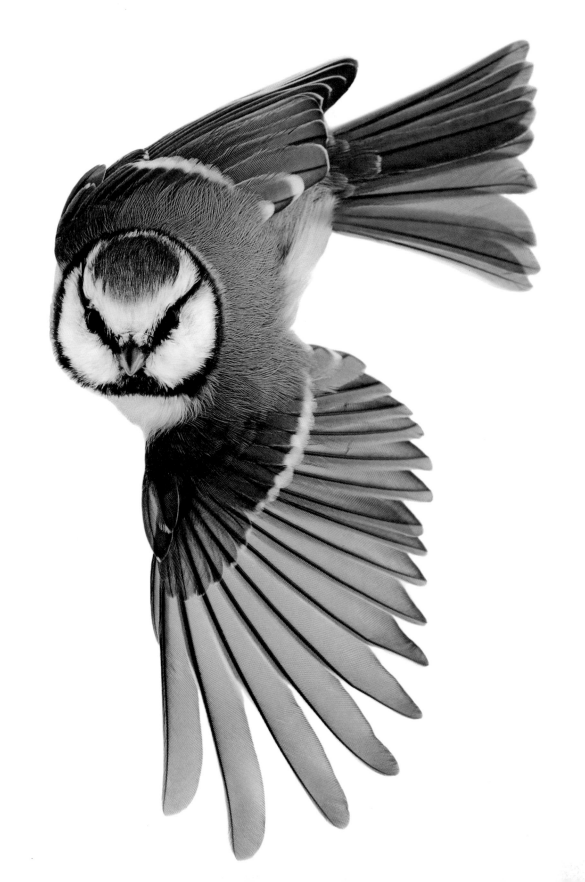

EURASIAN BLUE TIT. Author Bengt Anderberg had an eye for the character of birds. In his prose poem "The Impossible," he was amazed that two blue tits in his neighborhood survived the terrible winter of 1979, observing that these small birds' lives are "constituted almost entirely from zeal."

Even with the snowstorms they had the energy to divert much bigger birds like great tits, finches, and sparrows from the desirable food on the bird table. That's what blue tits do: their psyche seems to be made of steel. They're like little terriers in plumage. Humans sometimes get to experience this as well, especially those who do birdbanding. The blue tit is a master—perhaps the greatest of them all—at giving painful jabs and pinches to fingertips and cuticles. It hurts just thinking about what it must have been like at Sweden's Falsterbo Bird Observatory in the fall of 2012, when nearly three hundred thousand blue tits passed through in a rare wave of migration, and the birdbanders caught nearly nineteen thousand with their nets.

It might be surprising to those whose feeders regularly host these birds in the winter that the blue tit is a migratory bird. This type of tit is in fact highly migratory during the coldest months of the year, but we might not realize it since we can't tell the individuals apart. Those who visit the winter feeder are probably not the same birds that mated nearby in the spring. It might not even be the same bird as the ones that visited just a few days ago, but new travelers who've come from the north or the east.

But their migratory habits are neither regular nor very long in distance. That blue tits traveled in such big numbers as they did in the fall

of 2012 is exceptional; usually their movements are more like excursions than true migrations, as the birds fly around six miles per day.

But move around, they do. Almost constantly. Bengt Anderberg, again:

Everything they do is quick, short, abrupt, like small flames that flutter in strong gusts of wind from every direction. It's a surprise to read that a blue tit can live to be eleven years! What a dizzying sum of moments, reactions, and sensations, an infinitely twitchy series of sensations, an old-fashioned newsreel of neck-breaking speed, every second a threat to life, decisive, fateful, incomprehensible, impossible.

The excerpt perfectly captures how we humans perceive this bird. The tits themselves of course find the blue tit life neither incomprehensible nor impossible. In Sweden alone seven hundred thousand couples do precisely that, as though it were the most natural thing in the world, and they do it with such success that the species becomes more common every year.

Thanks to their penchant for human-proximate environments and their frequent residence in bird boxes in gardens and parks, and thanks to their regular visits to our winter feeders, blue tits are well-known birds.

In other words, we probably think we know what they look like. But we don't.

Not even when we study color photographs taken up close can we know what blue tits look like—not in the eyes of other blue tits. Because to each other, they're ultraviolet.

The male in particular, and especially his head. Scientists say that the ultraviolet color functions as a seal of quality. The stronger the color, the stronger and more excellent the male. And the female, astute at reading the signs, prefers a colorful mate to a paler one.

For us humans, who don't perceive ultraviolet light, this all takes place behind closed doors. We have no idea what the blue-ultraviolet beret on the blue tit's head looks like. But that did not stop artist and author Catharina Günther-Rådström from falling head over heels when a blue tit entered her life by chance:

I found a ragged blue tit chick on the ground when I was out jogging and I brought it home. We fed it with tweezers, giving it soaked puppy food. Absinthe—that's what we called it—recovered quickly and seemed comfortable with us. He'd jump around on the breakfast table, join me in my studio, and come along when we went to see friends. He'd sleep in a ceiling lamp in our bedroom. Early every morning he'd jump onto my pillow and pull my hair until I woke up. He wanted to eat, immediately! I learned to distinguish his sounds, so I understood if he was hungry, happy, or just wanted a confirmation that all was well. I'd peek back and he'd be content.

Once he'd learned to fly, he spent more and more time outdoors. It was a painful but happy turn of events when he got to know two other blue tits in our garden, turned more and more into a wild bird, and finally left us. Afterward my husband, Niklas, and I made a book about our adventure: Absinthe: The Story of a Blue Tit.

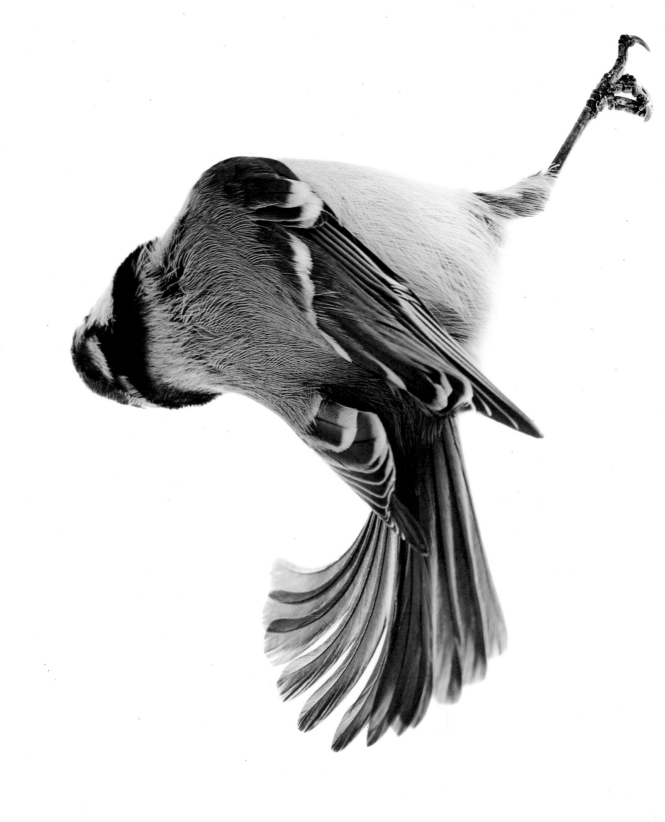

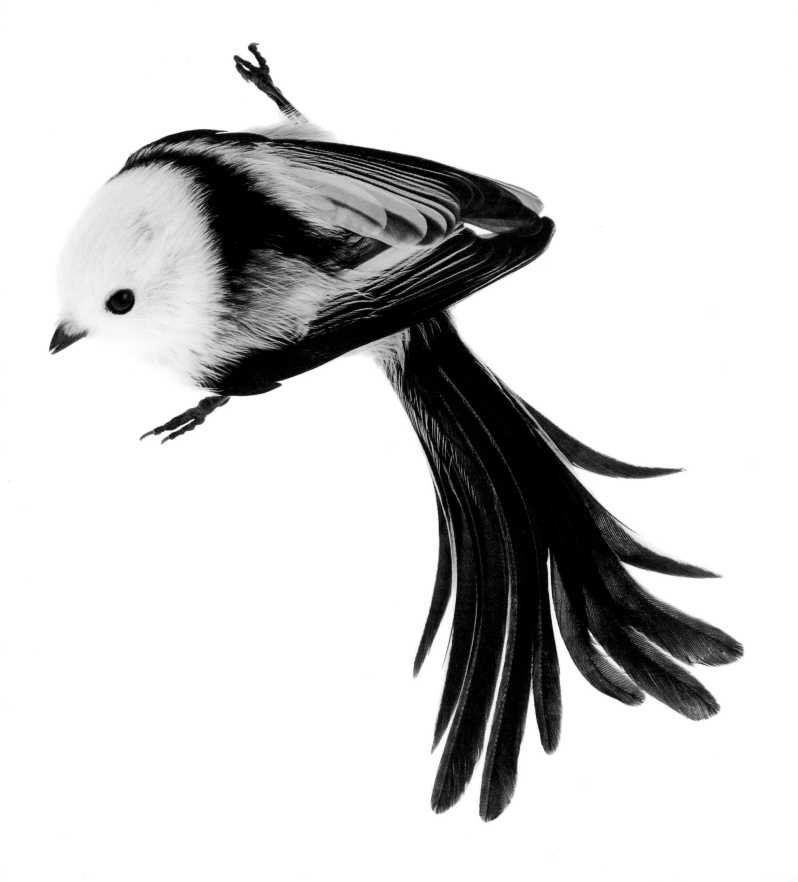

LONG-TAILED TIT. They want company. Always, always company. The long-tailed tit alternates between living in a nuclear family (during the mating season) and with extended family (during the rest of the year), but their reluctance to be alone is constant.

They are also not very likely to be still.

You have the biggest chance of encountering a long-tailed tit during the winter months when they swoop around their territory in family groups of about ten birds, volubly chattering.

It's usually the energetic creaking *krrr* that indicates a flock is nearby. The little gang of long-tailed down orbs—they look like pom-poms with a shaft—move from tree to tree, not all at once, but one bird at a time. *Krrr, krrrr!* Each time they're obliged to move across a more open space (and they really prefer not to) they gather close together, eagerly conferring before taking off in a long line. *Krrrr, krrrr!* Quickly, they go. As suddenly as they came, just as soon are they gone, and you find yourself smiling to yourself about the pleasant experience. The long-tailed tit can be an effective antidote to winter depression. It's impossible to look at them without feeling just a little bit happy.

The winter flocks are usually made up of a group of chicks and their parents, plus a number of adult relatives. Where scientists have been able to determine family relations, the relatives have turned out to be linked to the male in the parental couple—they might be analogous to single aunts and uncles.

The extended family sticks together in everything they do during the fall and winter months. Together, they defend the borders of their winter territory against other groups of long-tailed tits. And together, they endure cold winter nights that none of them would survive on their own. The smaller the bird, the harder for it to keep its body temperature in the cold. The long-tailed tit is tiny, at least if you don't count the long tail, and it wouldn't have a chance to make it through the northern winters if these birds didn't have the custom of spending the night together. During mild nights, the family members will sit with some space between each other on the same tree branch, but when temperatures drop, they curl up close to each other. It makes them look like one big mass of white fluff, with several long tails.

The birds that survive the winter split up into couples when spring comes. The long-tailed tit couple stakes out their own mating territory within the bigger family winter territory. Generally, young single females will travel to other big families in order to meet males to whom they have no family ties, while bachelors stay on their home turf and wait for new exciting females to arrive.

And thus begins the intricate construction of one of the most perfect artworks in the world of birds. The long-tailed tit's nest is a cocoon-like creation made by moss, spiderwebs, and hair; a round ball slightly extended in height and perfectly camouflaged with up to 3,000 lichen. On the inside, it's insulated with huge amounts of little down feathers.

In one record-holding case, a tenacious long-tailed tit researcher counted 2,680 feathers. No wonder it takes these birds up to a month to build their nest.

The transition from big family to nuclear family doesn't happen abruptly, but gradually. During the first portion of the construction process all the birds in the winter territory gather in the evenings to spend the night together on a branch, but once the nest has a roof, the couple begins to spend the night in their new home.

Even though the nests are well camouflaged in the treetops, they're often subjected to plunder. A couple whose brooding is interrupted will shift to help close relatives instead. One single brooding couple can have up to eight assisting aunts and uncles, and this support radically improves the likelihood of the chicks surviving and reaching adult age.

This collective care for the offspring, which is rare among birds on northern latitudes, is an important reason that researchers are so interested in the long-tailed tit.

The bird also inspires curiosity and warm feelings in the broader bird-curious population, largely because of its looks. Business developer Kajsa Grebäck is a fan:

The long-tailed tit is one of the cutest creatures I know. Once I saw up close how an entire group of them arrived, one after the other, and sat down, closely together, inside a hedge. It was so sweet. I guess they were going to spend the night there.

Where we live, long-tailed tits come to the feeder almost every day, and always as a flock. We feed them until late spring. When they've started making their nest, they look kind of funny because the tail gets tousled. Maybe the nest is too small for the long tail?

I really like the coloring of the long-tailed tit: the clean white, the pink-brown, and the contrasting black. They seem a bit drab when you first look at them, but they're actually quite colorful! I often pay attention to colors, it makes me happy.

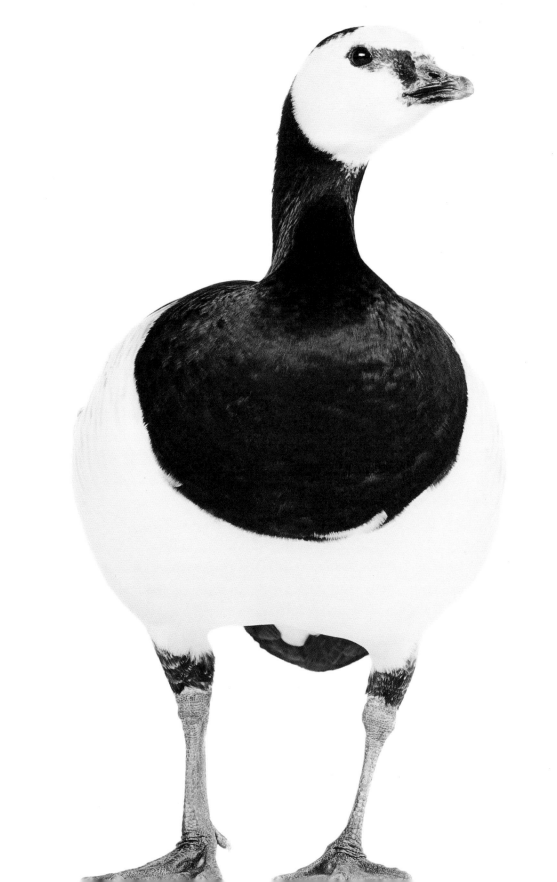

BARNACLE GOOSE. Historical explanations for birds' seemingly mystical appearance and disappearance with the changing seasons can seem as fanciful as fairy tales to contemporary eyes. One example is that swallows slept through the winter on the bottom of lakes, a myth that even great scientist Carl Linnaeus believed.

The story about the barnacle goose is at least as imaginative. Nobody in Western Europe had any idea that the bird mated in the Arctic. Neither its eggs or its chicks had even been seen—all people knew was that every fall, great numbers of adult birds suddenly appeared in their winter territories.

The generally accepted account was that these birds grew from barnacles, a type of crustacean that spends its life attached to rocks, stones, or driftwood at sea. The myth can still be found in its name, barnacle goose, just as some of the most gooselike barnacles are called, that's right, goose barnacles.

Only a tiny bit of imagination is needed to see a goose head with a dark neck in the barnacle. So, it might not have been as crazy as it might seem today that the Welsh twelfth-century historian Giraldus Cambrensis and many others thought that the crowded colonies of barnacles were embryos for the thousand-headed goose flocks that came each fall. (Since the species was conceived of as both goose and crustacean, it wasn't considered meat by the church and, therefore, a permitted food during fasting. This decree probably made the misconception particularly stubborn.)

In time, people recognized that goose chicks hatch from eggs, just like all birds. But the Arctic mating territories of barnacle geese are not quite like the territories of other birds. Traditionally, they construct their nest on a rock shelf of a steep cliff near the Arctic Ocean. The advantage of such a location for brooding is that it's inaccessible to polar foxes and polar bears. The disadvantage is that the chicks, at just three days old, must take a dizzying leap straight into thin air to join their parents waiting at the base, sometimes four hundred feet below. You might have seen the BBC's terrifying footage of baby birds tumbling and bouncing down the rock face in a plummet that seems to go on forever before they finally, miraculously reach the ground unharmed. Far from all of them make it. But enough do for the strategy to be worth it.

For a long time, the barnacle goose was known in Scandinavia as nothing but a transient guest, stopping by in the fall and the spring on its way to or from the Arctic Sea and the tundra. Fifty years ago, the barnacle goose still retained an exotic air, particularly compared to the somewhat-scorned Canada goose, which had been brought from North America and then taken up residence at just about every other lake.

This was until the 1970s, when the barnacle goose went from being a distant bird to a bird in close quarters to humans.

It was a transformation that came about in two ways.

First, some of the geese who traditionally took a break on the small island formation of Laus Holmar in Sweden decided to not continue

their journey to the Arctic. They stayed and brooded on these rocky islets instead, a fully understandable choice. The water separating the flat islands from the mainland provided the same kind of protection against foxes and other predators as did the Arctic precipices, but there was no need for the chicks to take a dangerous tumble.

The trial clearly yielded the desired results, because the birds expanded their new territory from this bridgehead to the island of Öland, and later onward to multiple locations on the Swedish mainland.

Secondly, something happened at the Skansen zoo in Stockholm, where barnacle geese had been kept with their wings clipped for decades. One year in the 1970s, their keepers abstained from clipping their wings, and the chicks responded by taking off. Today, the offspring of these now-feral birds alternate nesting spots in Stockholm. They waddle nonchalantly between joggers and stroller-pushing walkers, completely unperturbed by their human company and rather unwilling to give up any of their space. Not long ago, the bird was known solely as a passerby from the Arctic wilderness, but today, partly by its own wits and partly thanks to a little bit of help from its human friends, it's become a very common goose.

Some people think it might have become a little too comfortable in its proximity to us. The barnacle goose is temperamental, something Regina Lindborg, professor in the Department of Physical Geography at Stockholm University, has been made aware of more than once:

I am of two minds when it comes to the barnacle goose. It's incredibly beautiful and pretty, but also extremely aggressive. I know, because I've counted their nests for the county government since 1995. When you approach a nest, the bird will curl up and hiss angrily, but it might also attack and try to bite you. If you look away, it might sneak up and jump you from behind! I've learned to handle it, but I've taken a few hits.

Their behavior can be annoying, but I can't help but find their toughness cool. It's strategic to act this way—it means they get to be wherever they want. You see them all over the parks. If a human gets too close, they'll hiss, looking pissed. People who picnic tend to huddle together for protection when a goose approaches.

Me, I almost automatically start counting as soon as I see a flock. How many are there? How big are the chicks? It's become a bit of an obsession for me.

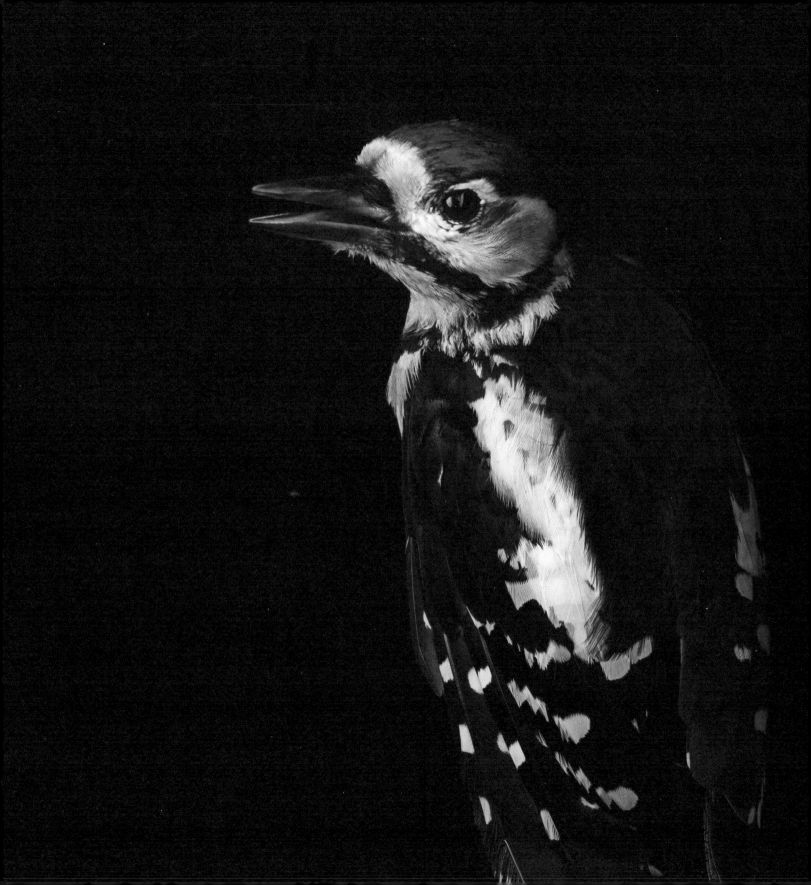

GREAT SPOTTED WOODPECKER. Even a person who can't distinguish a great spotted woodpecker from, say, a middle spotted woodpecker, usually knows what woodpeckers are as a group. They are so distinct in their behavior and have such particular arrangements for their vertical lives: the stiff tail that functions as an additional supporting leg against the tree trunk and the powerful beak, for example.

But of all the things that make a woodpecker a woodpecker, a feature hidden inside the bird is the most surprising.

A body that accelerates or decelerates is subjected to forces measured in the unit g (for gravity, not gram). A human will suffer a concussion if she's subjected to a direct impact to her head at 80 to 100 g. Woodpeckers subject themselves to forces over 1,000 g when they hit their beak against a tree trunk with full force. And they come out of it just fine, thanks to a whole host of different custom-made features of the cranium and brain.

Without these shock absorbers, most activities of the woodpecker would be impossible. It makes its nest cavity by hacking it out of a tree trunk (and thus also provides other bird species with nests to sublet). It gets food through hacking it out of tree trunks. And it picks up partners by drumming its beak on dry tree branches and other materials that offer good resonance.

The construction and food hammering can most readily be compared to a person using a hammer and chisel: the swings are infrequent and

irregular, a little ad hoc. But the flirty drumming—the direct counterpart to the song of the smaller birds—takes the form of distinct drumrolls that are so fast that humans can hardly perceive the distinct beats. This percussion only takes place in springtime, and it's more or less unique to the different types. A trained ear can fairly easily separate, for example, the great spotted woodpecker's quick, short drumroll from the black woodpecker's long rough creaking (the latter sounds like a cross between a slow machine gun and a barn door in need of lubricant).

In Europe, contemporary foresting's preference for densely planted spruce trees has been a true boon for the great spotted woodpecker, since its most important winter food is seeds from the spruce cone. It has a very elaborate method for extricating them. Once the woodpecker has chosen a cone, it holds it in its beak as it flies to a tree specifically picked as a so-called woodpecker smithy, where a cut in the wood has been shaped to perfectly hold a cone. Now, the woodpecker wedges its "prey" in the hole to free its beak for plucking the seeds.

We had such a woodpecker smithy in the maple tree in front of our porch last year. Every day that winter new battered cone carcasses lay under the maple. People asked why we were sanding our gravel road with spruce cones.

Having a woodpecker smithy in your own backyard is a question of luck, not skill—either you have a tree that appeals to the bird or you don't.

But a person who wants to get so close to the woodpecker that she can look into its rusty brown eyes might offer it some tallow, lard, butter, or margarine. Fatty sunflower seeds also work well, as retired teacher Berit Bergström learned during a recent summer:

You might think a woodpecker would frighten smaller birds, but it doesn't. It just sits at the bird feeder eating calmly, or sometimes it's on the ground, in the midst of the other birds.

We've been feeding birds in our backyard even in the summer for the past few years, since we want our grandchildren, who visit during that time, to see the birds up close. It works out just fine. One time two woodpecker parents brought their chick. It was larger than its parents, pretty scruffy, and it sat on a branch in the birch tree less than ten feet from our window. We were inside and watched as the parents fetched sunflower seeds, one at a time, put them in a slit in the branch, peeled the seed, and fed the chick with it. The male, whose chest looked almost dirty, and the female who was bright white, took turns as the chick sat absolutely still and just waited. What a show!

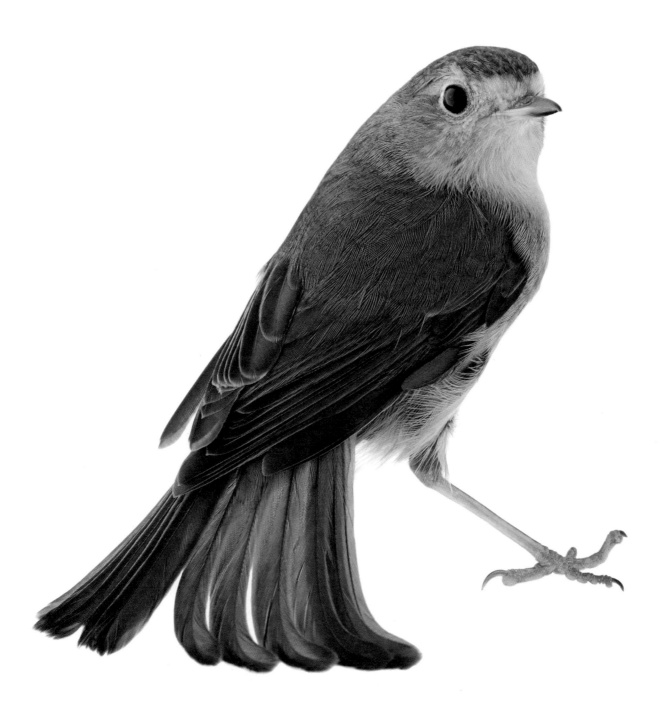

EUROPEAN ROBIN. Long ago, Zenodotus of Ephesus, manager of the library in Alexandria, knew that European robins are grumpy loners. Around 300 B.C.E. he noted, "Unicum arbustum haud alit duos erithacos" (a bush cannot hold two robins): Antiquity's version of the popular saying of the Wild West: "this town ain't big enough for the both of us."

The biological explanation for the bird's morose behavior is that European robins are committed to protecting their territories year-round. They mark their little turf even during the winter months and aggressively defend it against infringing robins.

European robins are just as eager to pick a fight during the mating season, but then they go in as a couple: you and me against the rest of the robin world. About a century ago, the British scientist David Lack paid a shilling for a lesser secondhand European robin—a taxidermied specimen, that is—and placed it in various robin territories. He didn't have to wait long to get feedback. Irate males and females defended their territories with great vigor, often with violence. At one point a female robin attacked the flea-bitten intruder with such intensity that its head fell off, a development that did not in any way slow her rampage.

Lack was curious about what aspect of the taxidermied bird inspired the aggression. Using a method of exclusion, he found that it was the red chest. An otherwise lifelike European robin without a chest patch was left alone, while a rudimentary model of a bird that was essentially made of nothing but a red patch was ruthlessly attacked.

Despite its temper, the robin is one of the most beloved birds in all categories. This is evident from the abundant comments left on every picturesque robin photo published on social media. And how could it be otherwise, with those looks! It's like the robin was designed to be loved. Its straight posture and the bouncy jumps on two feet give the bird such a vivacious countenance that just the sight of it is enough to make you stand a little taller, walk a little lighter. Moreover, it's so cute that only the long-tailed tit can compete, using the same means: soft downs that it can puff up into an almost perfectly round shape and big dark eyes.

Interestingly, the eyes explain why it sings so early in the mornings. Small birds generally avoid singing if they don't have enough visibility to detect threats, but the robin's big eyes give it enough night vision to consider singing *before* dawn has broken. And with their big eyes, they keep singing through dusk, long after the rest of the bird choir has packed up and called it a day.

And we listen, our ears big. A robin solo performed on a spring morning that's so early it might as well be called night—it's a holy moment. "First, the song plunges me into gloom, but only to soon lift me higher than high, carrying me to a feeling I recognize from my most lovely experiences," writes author Björn Berglund.

Between September and October, any friend of robins with a garden of their own should get ready.

During this time, it's as though the robin loses some of its distrust in humans, and a gardener might get company as she's digging in her flower beds. She'll find the little hermit serenely observing, perhaps perched on the handle of a wheelbarrow or the spade, as though looking for company. In reality it's more likely to angle for the shovel to expose insects it can eat.

Whatever the case may be, it's a moment to cherish. Soon enough, the robin leaves Sweden to go south. In slightly warmer climates you might be lucky enough to have company year-round, as robin lover and kindergarten teacher Annika Gustafsson observes:

There's a park next door to us, but the robin has chosen to stay right here, in the small garden we share with our neighbor, not bigger than a quarter square mile. We have a sixteen-foot-tall maple and two huge rhododendrons. Under it is a flat stone where I often put apples and raisins for robins and blackbirds. They like to come eat from it.

Our robin is not the least bit intimidated by our house cat. He coolly stays on the wire fence when the cat comes, sometimes just a few feet away. And the cheeky, confident bird just sits there with his beautiful red chest, chattering. He's demonstrating: "I live here!" It's as though he understands that this cat doesn't hunt birds, because that's the case.

If I get too close, it does move, but just a little bit. "Alright, I guess I'll sit here then!" I love it!

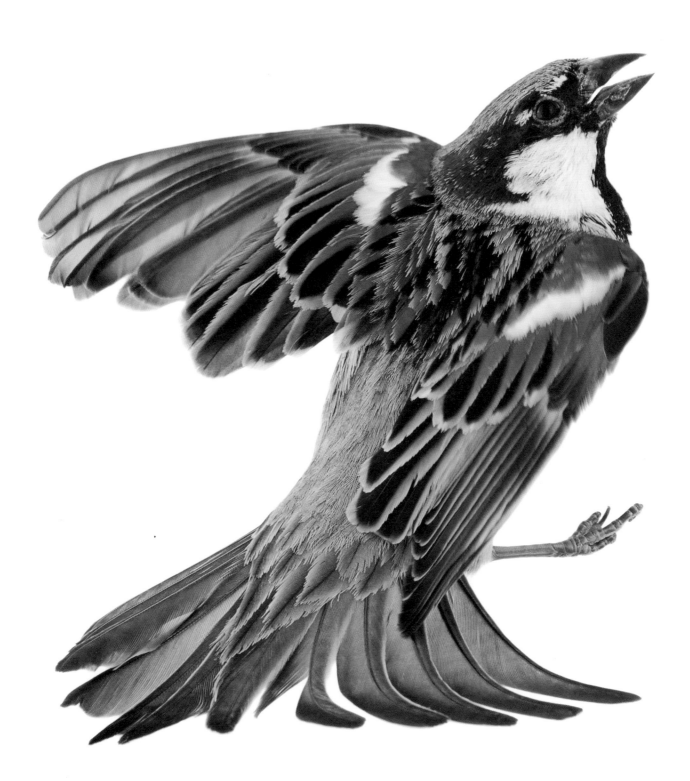

HOUSE SPARROW. You can't help but feel a little warmer inside every time you walk past a twittering bush and hear the voluble kitchen chatter of the house sparrows. House sparrows are so genuinely social that they're almost incapable of silence. They have an endless need to make sure the others haven't gone anywhere and that all is right and well in their world. They're at work on an important project, writes poet Werner Aspenström, to "live another day and another night."

His and other poets' love for the house sparrow probably stems from the way these birds are such gracious representatives for humility and everyday heroism. There are probably quite a few of us who feel the need to protest against too much sensationalism, against excessive focus on strong colors and extreme showiness. Sometimes we want to praise the ordinary, all that which the house sparrow represents. To live another day and another night and another day, that's life, after all.

Not that they're so terribly gray; especially not the male, who really glows. And the bird is not particularly common anymore either, at least not everywhere.

But let's start from the beginning.

The house sparrow originally hails from the Middle East, and there must have been a time when they lived all alone, without human company, and fed on wild seeds. But soon they realized that it paid to stay close to the bipeds, because they could provide grub. The house sparrow began

to eat grains, and when grain agriculture took over the world, the house sparrow did too.

This bird is far from a long-distance flier, so its conquest was slow, following the tracks of humans and their horses, who were traveling north through Europe before arriving at Scandinavian latitudes. The house sparrow is keen on horses, because where there is a horse there's always a bit of spilled grain feed and a few undigested seeds in their poop.

Suddenly the house sparrow was all over, getting comfortable everywhere there were humans. A little *too* comfortable, some humans felt: the house sparrow was often viewed as a grain thief and an airborne rat and was fought accordingly.

These birds even crossed the oceans. Sometimes they emigrated on human initiative, as when they were introduced in New York City in the 1850s as a corrective to harmful insects. But they became so large in number that it wasn't long until they themselves were understood as vermin. Sometimes they chose to migrate independently; Denis Summers-Smith gives multiple examples of such journeys in his classic *The Sparrows*. He describes how twenty house sparrows colonized the Falkland Islands in 1919 by hitching a ride with whaling ships when they left Montevideo, Uruguay. Another example is the four house sparrows that boarded a ship in Germany's Bremerhaven on July 14, 1950 and didn't get off until they arrived in Melbourne, Australia.

Today the species is the world's most common small wild bird.

But even though the house sparrow keeps growing in numbers in some parts of the world, the flocks are shrinking in many areas of Europe. The situation is probably direst in England, where the dwindling numbers have been met with a sort of low-intensity national mourning.

One partial explanation to the setback might be that there are no horse carriages in the cities anymore, and that human dwellings tend to be cleaner and more orderly. And it is increasingly difficult for sparrows to find insects, both in the cities and around a lot of contemporary farms. This dearth of insects is devastating, because even if adult house sparrows feed on cereal, the chicks need to eat aphids and other bugs during their first days, or they'll starve.

In any case, the good news is that the decline of the house sparrow appears to have plateaued, at least in Sweden. It looks like the numbers might even be growing slightly. Trauma therapist Gunilla Hamnes is overjoyed:

Many will say that it's just a house sparrow, but for me it's the opposite. I love to see magic in the ordinary. The house sparrow is my friend. When others shoo them away from the café tables in the city, without even seeing them, I like to think that they're keeping me company. I don't understand how people can so routinely ignore the house sparrow—they're incredible creatures. I travel a lot and see them here and there, especially in Europe. It

feels like home. They're always where humans are. They live in our cracks and in-between spaces.

When you're out walking in the winter, it can sometimes seem like an entire bush is alive with house sparrows. You hardly see them because they have the same colors as the winter itself. It makes me laugh. What are they doing? What are they chattering about?

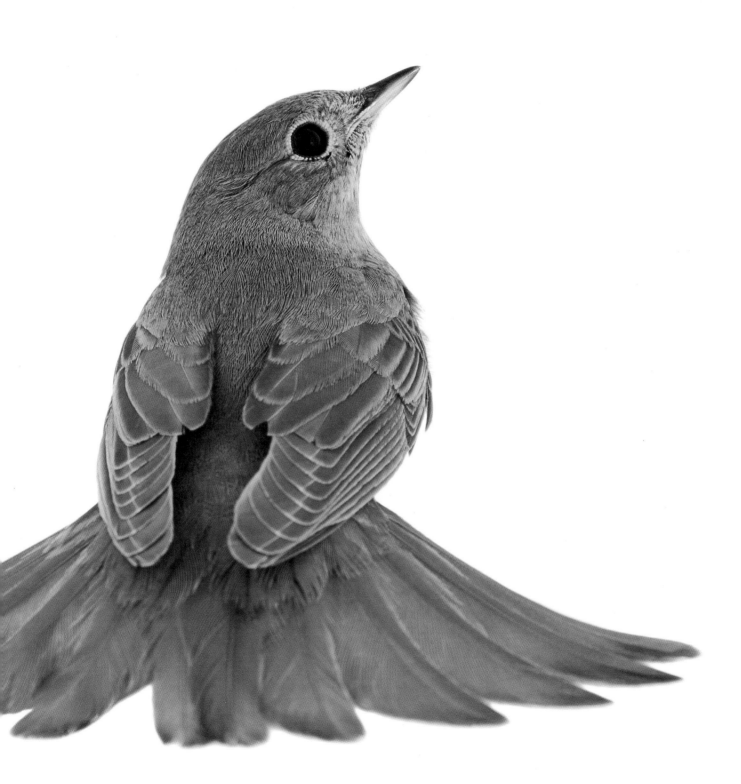

THRUSH NIGHTINGALE. You can go through your whole life as an admirer of the thrush nightingale without ever seeing the bird: it's almost always hidden inside a cloud of chlorophyll.

But you hear it loud and clear from the greenery, sometimes a little too well. The presence of most birds is greeted as a treasure and a blessing, but even a devoted friend of birds may prefer the nightingale to keep some distance from their bedroom window. It sings throughout the night, and sometimes even during the day. And it can reach a notable pitch. The species' noxious effect on sleep is illustrated in Stefan Sundström's song "Nightingale," where the main character in desperation cuts down an old beloved apple tree in order to get the nightingale to move so peace can return to the summerhouse.

But wait a second—isn't the nightingale known for its unusually beautiful song? Consider all the romance and all the sonnets; consider poets like Milton and Keats, all their "O Nightingale" and "sing'st thou." Consider the nightingale's tendency to place at the top of the list of the most skilled songbirds, not least in Scandinavia.

All this is true, but there is a misunderstanding here. Scandinavians listen to a different nightingale than Brits and Central Europeans. Swedes call the southern variant southern nightingale, whereas its English name is common nightingale. The bird that in Sweden bears the name of nightingale is called thrush nightingale in English. The name indicates that Swedes, consciously or unconsciously, consider the

common nightingale a southern variety of the "real" nightingale. And, of course, the relationship is the inverse for Central and Western Europeans. In their eyes it's the Scandinavian species that's an exotic variety of the "real" nightingale.

The conclusion is that the continental and British birdsong connoisseurs are praising the *common nightingale*. But it, too, sings with great force. A German scientist who measured the volume of common nightingales in Berlin found it singing at a volume up to 95 decibels, which is apparently as loud as a motor saw at a distance of a few feet. But most importantly: the common nightingale sings more beautifully. It has a more melodic and varied song and is slightly less brutal.

Since most people don't tend to distinguish very closely between nightingale and nightingale, the Nordic nightingale has been mixed up with its southwestern relative and thus earned a more flattering reputation than it perhaps deserves. It's a good case study of how culture can infiltrate our perception of a species.

But still, the thrush nightingale's song is fascinating and moving—perhaps even beautiful, in its own way.

Forest manager Monica Gyllenstierna doesn't hesitate in crowning the species her favorite:

You almost never see this little unremarkable bird, but its song is amazing. I associate it with early summer evenings and white nights in the period between the flowering of the bird cherry and lilac.

Where we used to live there were several nightingale males that competed. I loved it. After a while you could get a little fed up with them singing in every direction, but it was still easy to tolerate because you knew they would always stop singing after midsummer, when it would be dead silent.

We've moved and left the nightingales now, but I think of them every year. It happens that I have an errand in my old neighborhood and I get to go back and hear them again. I always stop and smile . . . it's so nice!

I've also used my favorite bird in an attempt to raise my sons to be gentlemen. I've told them to say that "The nightingales of my heart sing only for you" when they want to win the heart of a girl. My sons roll their eyes and tell me you don't use phrases like that anymore.

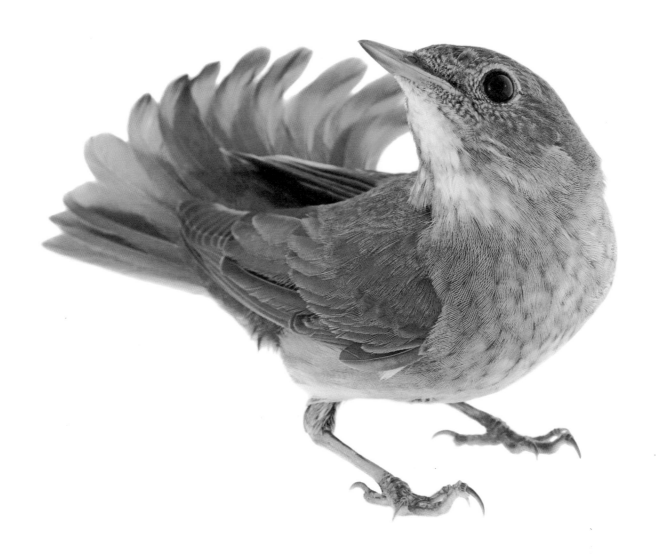

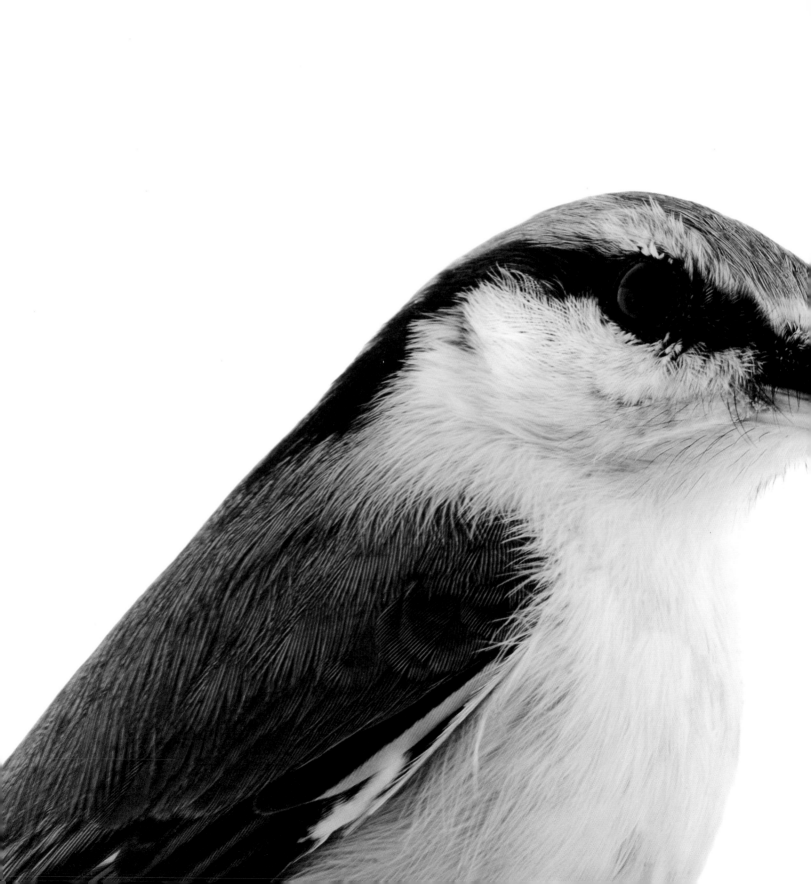

EURASIAN NUTHATCH. The first thing people tend to learn about the nuthatch is that it can climb, headfirst, down a tree trunk, a feat it is singular in mastering. Next, you might be told that the female is a skillful mason who knows how to use clay to shrink the nest hole to the perfect nuthatch size, or that the nuthatch couple is very loyal to their home and stays in their personal territory every day, year-round.

This is all exciting and idiosyncratic, but let's leave the biological perspective behind for a second and instead consider the nuthatch as a possibility for a relationship, an exercise in closeness.

Because there seems to be something about this bird in particular that invites such activities, at least if you listen to the poets.

How would it feel, asks American poet Kirsten Dierking, if a nuthatch flew down from a tree and offered to sit on your left shoulder during all your everyday walks: from the garage to the house, from the house to the mailbox, from the store to the car in the parking lot? The right pressure in the little claws. The flutter of wings in the corner of your eyes. She asks if having a nuthatch on your shoulder would be nicer than being alone and having to think of something to say to the people you encounter.

Even more concrete is Mary Oliver, one of the most beloved contemporary American nature poets. In her poem "Winter and the Nuthatches," she describes the feeling that emerges when she, after hours of stubborn waiting in the snow, finally gets a nuthatch to sit in

her hand and eat walnuts, and when she arrives later one day only to discover the bird sitting in the hand of a stranger. You can't own the heart of a bird, she says, but she'll try again early tomorrow.

These poems are about a different—although closely related—type of nuthatch than the Eurasian kind, but the distance is short from Dierking and Oliver to a cherished Swedish bird book: *Conversations with a Nuthatch*.

It all began one hot summer in the middle of the 1950s when poet and artist Björn von Rosen would sit in his garden and work. For company, he had a nuthatch, which was unusually daring in its search for food on the ground right next to him. Von Rosen began to devote more attention to the bird and finally it was so relaxed with him that it would eat from his hand, come along on his daily walk to the mailbox, and sit on the windowsill looking in once he'd gone indoors. The book is saturated with the everyday joy that comes from feeling connected to another living being, someone different, but still similar.

The bird was given the name Pumpkin and remained von Rosen's friend for more than nine years—speaking of the nuthatch's loyalty to one location.

You can read *Conversations with a Nuthatch* as a manual in the art of getting close to a bird—no feat at the outdoor cafés of the city centers, but a great challenge when it comes to country birds who have maintained their natural shyness.

Von Rosen explains that anyone who wants to experience that moment when the bird at last ventures to land on the open hand has to arm himself with patience:

There is no point in attempting some such thing if you are not feeling relaxed and harmonious, with plenty of time on your hands. Even the slightest whiff of impatience seems to be perceived by the bird, who immediately reacts by turning its head or—when it comes to the nuthatch—climbing the tree even higher.

The book could even be considered a manual in humility. It teaches that closeness to a bird isn't a right, but rather a blessing that we might be granted. There's no point in even trying before the bird has shown its own interest, writes von Rosen: "The only thing you can do is to carefully, thoughtfully, take advantage of the situation when it arises."

When he later looked back on his time with Pumpkin, he defined it as something absolutely outside of the ordinary, like a piece of experienced poetry. Perhaps dog-store owner Elin Mattson's unusual encounter with a Eurasian nuthatch can also be described that way:

As soon as we'd entered the church I noticed the nuthatch flying around inside. It was easy for me to determine what kind of a bird it was, since I was very interested in birds as a child.

My niece Hilda was going to be baptized that day, and we had planned a ceremony in medieval style during the local medieval fair. Visiting that fair is almost more exciting than Christmas for our family—we're all nerds about the Middle Ages.

I was wondering what the nuthatch was thinking: Was it trying to get out? Was it just having some good old fun? It didn't seem stressed at all.

Once the ceremony started, it landed on the cross at the pulpit. It didn't move until we were done, when it began to fly around again.

I've asked myself what that was actually all about. Was it a visit from a relative in the shape of a bird? Such thoughts come easily to me. Whatever it was, the encounter with the bird was a very special event. I ordered a tufted nuthatch from an artisan at the market and gave it to Hilda as a delayed baptism gift.

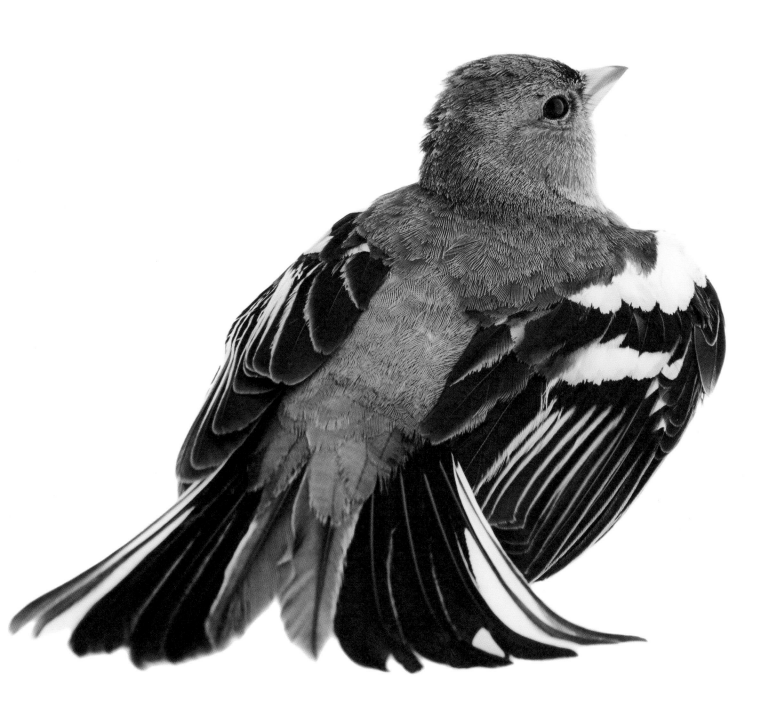

COMMON CHAFFINCH. If the species wasn't so ubiquitous in Europe, it would probably be easier to see how attractive chaffinches actually are. Especially the males during springtime, when the shades are brightest. Their coloring is daring—few people could pull it off. But the chaffinch male does it with style. The female, too, possesses a refined beauty, at least seen up close. She's like a color map that shows how varied the hues of beige can be.

But it's rare that people bother to look. When it comes to attraction, some birds are simply too pedestrian to succeed in asserting themselves. Imagine needing to wade through distant swamplands to have a chance to possibly, but only with great luck, spot a chaffinch. What a dream bird it would have been!

As it is, the struggle lies elsewhere: in really *seeing* the chaffinch, by looking beyond the gray screen through which we see the well-known.

Poet Ingrid Sjöstrand does not let herself be desensitized or struck by chaffinch boredom. She sees the return of a little more than eight million male chaffinches to Sweden in early spring as a triumphant victory lap, with thickets occupied by perfectly maneuvering male chaffinches.

The same poet has another poem where the male chaffinch sings his song incessantly, such that the joy comes filtering through cracks between windows, under basement doors, and through pantry air vents: "lifeissogreaticanhardlybelieveit."

But the poem's ending is laconic, alluding that night cold might bring an unexpected end to the chaffinch's life.

And that's of course the way it is: the chaffinch, like every other bird, walks a thin line. On the one hand, bare survival can often be a challenge, but on the other hand, all energy must be dedicated to finding a partner for making new chaffinches.

The chaffinch male's greatest weapon in the latter struggle is its song: the peppy waterfall of tones that ends with a little whirl, like Sjöstrand's "lifeissogreaticanhardlybelieveit."

Once the male has caught the interest of a female, he adds to his song short bouts of flight where his wings flutter like a moth and funny little dances that are meant to showcase his male charms. But the song remains his most powerful weapon in the quest for the female yes. He sings for her and for the male rivals around him. Neither the chaffinch nor any other bird sings for human ears.

Knowing this, we can still hear and be moved by the melody. Some of us are touched for life, like tourism specialist Sofia Gustafsson, who's had a particularly close relationship to this species since a male chaffinch inspired her interest in birds.

There was a knotty, tall apple tree that hadn't been pruned in ages outside the house where I lived as a student. Outside our kitchen window on the second floor, in the treetop, a male chaffinch would sit and sing all spring every year

for several years. It had such beautiful colors, a gutsy demeanor, and always made it feel like spring had arrived. Just imagine a chaffinch in the midst of all the apple flowers, singing for life! It was pure joy.

I didn't know much about birds at that point, but I began to feed small birds and bought a couple of bird books. Today, birding is a major interest for me, but I still shout "CHAFFINCH" as soon as I see one. My friends are probably a little tired of it.

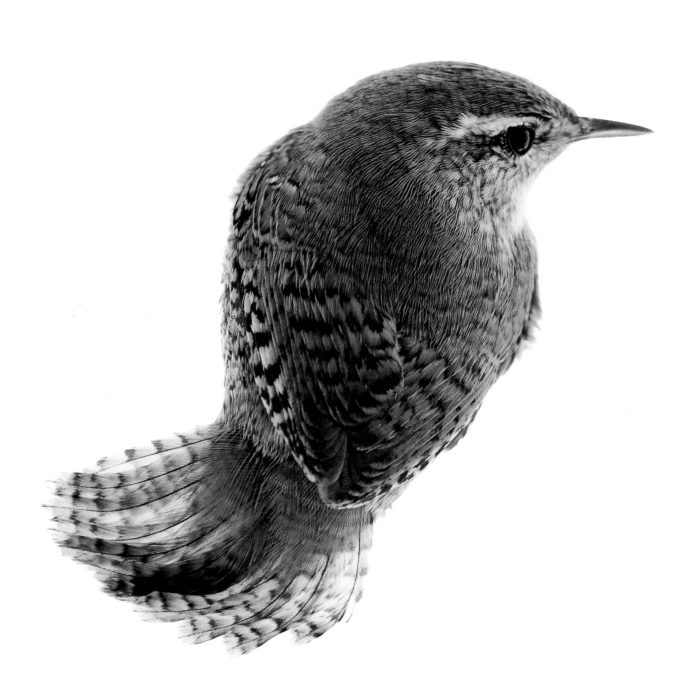

EURASIAN WREN. If, while walking in the forest, you hear something rattling insistently from between the fallen tree trunks of the undergrowth of the forest, you should pause and have a careful look. It might be the wren, described by poet Ted Hughes as an inspector of the forest's hidden places.

In some places in Sweden the wren used to be called the "tiny thumb." And you can see why: the bird is so small and plump that Nan Shepherd's mistake, chronicled in *The Living Mountain*, makes sense: "And once in Glen Slugain a pair of golden bumble bees (as it seemed) sped past me in a whorl of joyful speed. But it couldn't be—they were too large. I stalked them. They were young wrens."

To feel comfortable, the wren prefers environments full of crevices and shrubbery, where it's easy to hide. A gully in the forest is typical wren territory, but it also seems to accept gardens littered with shrubs, compost piles, stone walls, and woodpiles.

But there's no sneaking around when the eager little charmer breaks out in song. The rattling warning call is clear enough, but the blazingly intense song is even more penetrating. It's hard to fathom that such a small body can hold so much sound. Small birds tend to have sounds that match their size—the goldcrest, for example, has the thinnest of bird voices. But the wren . . . well, it's full throttle and the loudest pitch from start to end of the explosive melody. A singing wren is said to have a voice *ten* times more powerful than a crowing cock, if you count decibels per grams of body weight.

Even in the middle of winter it's been known to fire its acoustic machine gun, singing to defend its spot on earth against fellow wrens.

The wren is also notable for its eggs. Their taste is awful.

We know this thanks to zoologist Hugh B. Cott, who dedicated part of his career to testing how well different types of bird eggs taste to hedgehogs, rats, ferrets, and cats—as well as a human taster panel. Single-species egg scrambles were cooked under scientific conditions using a steam bath contraption and were then tried in a blind experiment by the panel, who graded the samples. In 1948, when 81 bird species' eggs had been tasted, a partial study was published. The wren came in last, with a score of 2.0 (out of a maximum of 10). In their continued work (a total of 212 eggs from different birds were tried), the panel was able to find an even-less-palatable species—the coal tit—but the fact still stands: wren eggs are far from tasty, neither to men nor beasts.

Egg tasting is an odd sidetrack in the human relationship to the wren. Wren eggs, like the eggs of any other wild bird, are best enjoyed hatched, as living birds. And many of us do enjoy the wren this way, pausing and letting ourselves be moved by the thumb-sized creature who appears suddenly, with its tail vertically angled to the sky, filling the forest with song, entirely unaffected by its insignificant size.

For some, it's a special relationship. That was the case for the father of author and journalist Johan Tell:

My father knew a lot about birds in general, but the wren was the only one he talked about as something special. It was almost his spirit animal. He felt a connection to it—I see it symbolizing the world of his ideas somehow.

Throughout the generations, the men in my father's family worked as metalsmiths; he grew up in the smith's house of a powerful estate. But he turned his back to machismo, drinking, smoking, and card playing, and became a different kind of person. He turned into a reader, a spiritual seeker, and an outdoor person who often went hiking, up until his death actually.

When we received the documents detailing his funeral wishes, all they contained was a map with a mark where he wanted his ashes strewn. When we arrived, we realized that the location was not in the beautiful beech forest but in a nondescript, scraggly mixed forest. We found a stream with a small island of eighty square feet that my father had called Eden. There! We got to arrange it, my brother and I, and it felt good. I imagine that wrens, too, like this place.

My father was an inventor all his life. When I turned forty, he gave me a pinwheel he'd made from bike wheels, six cone-shaped funnels that give speed and at the top, a weather vane made by cups that shape a wren. We've put it outside our summerhouse, a nice memorial. Sometimes I see a wren in the oak tree outside my office there. My father always tried to pass his interest in birds on to me, without being very successful. His name was Gunnar, by the way.

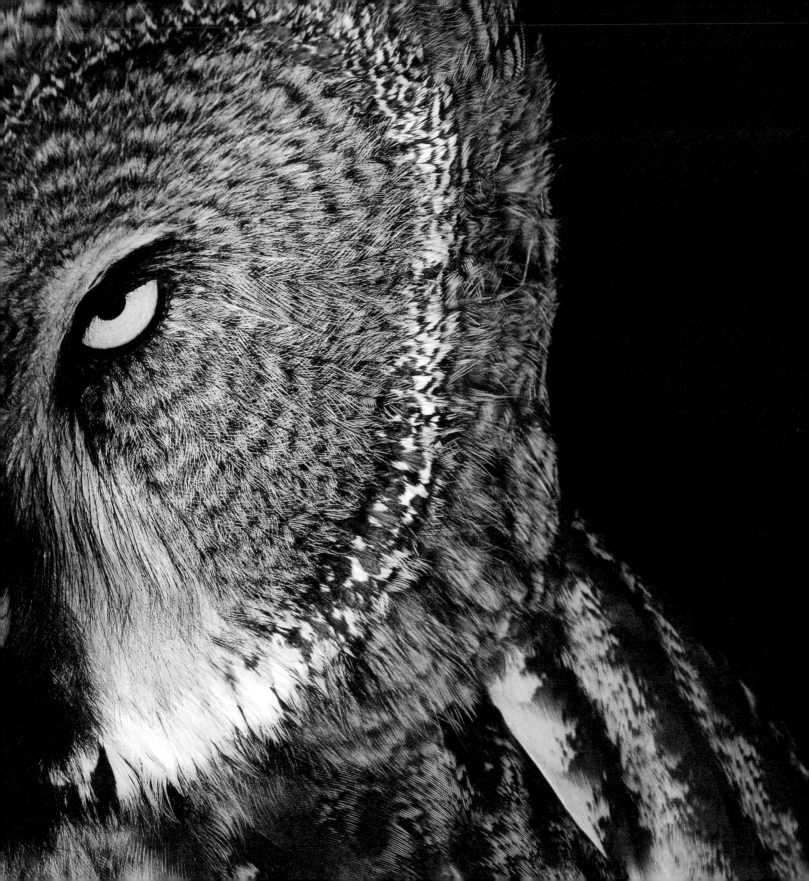

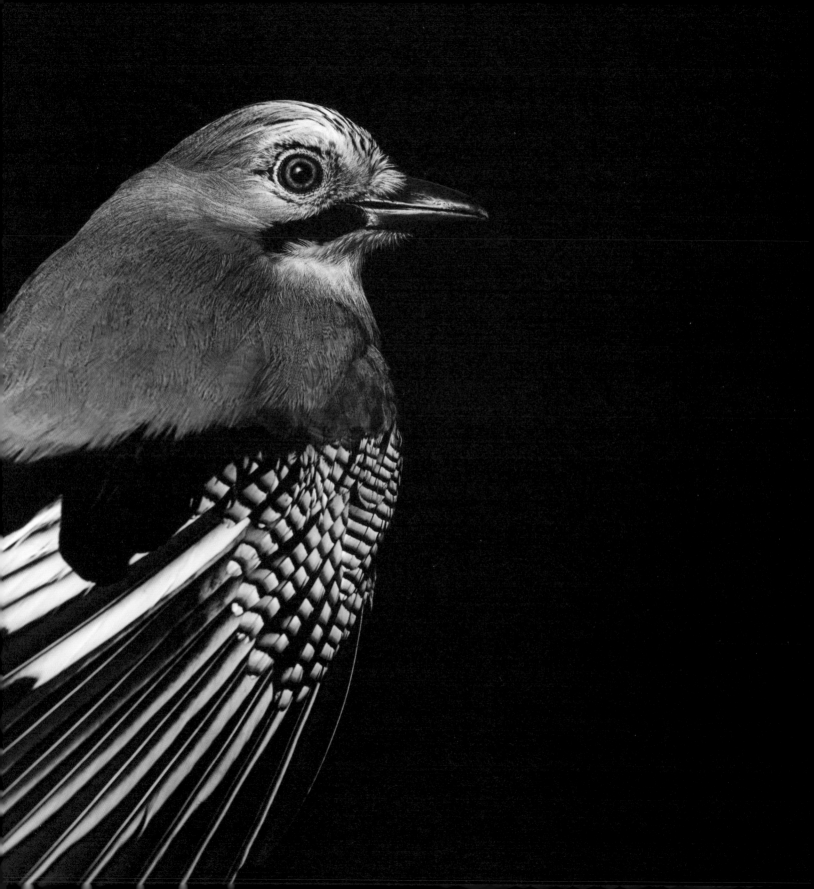

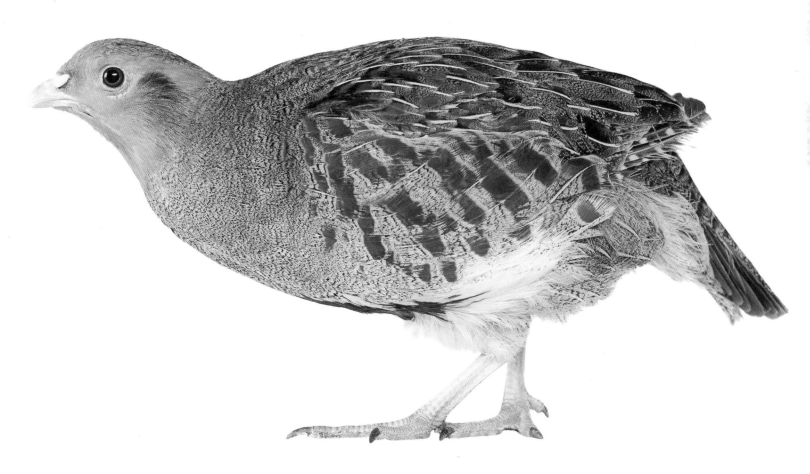

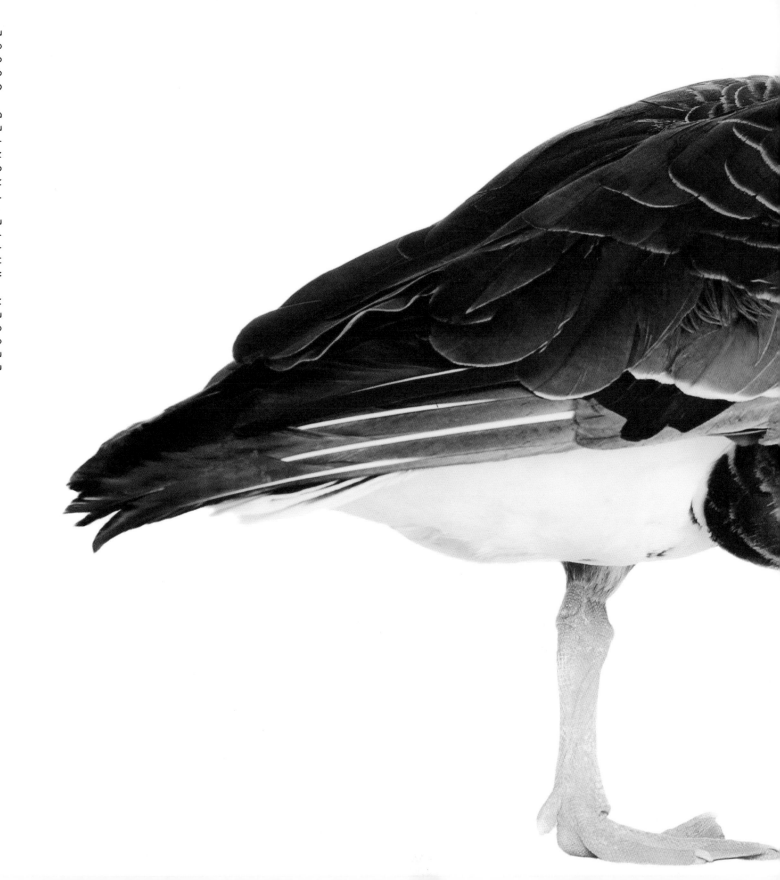

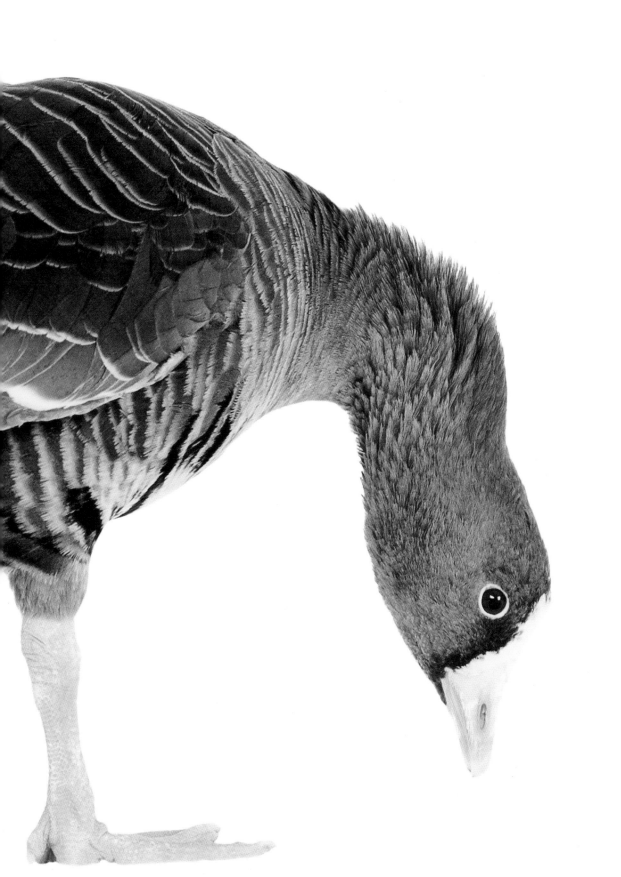

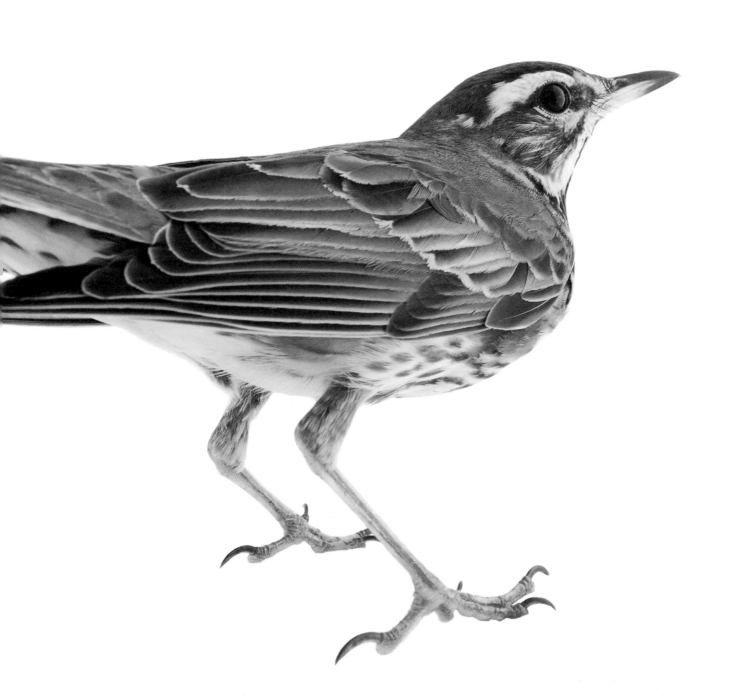

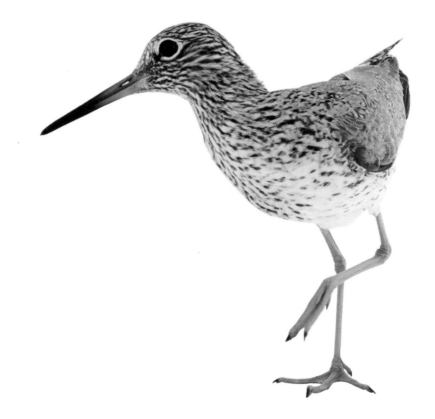

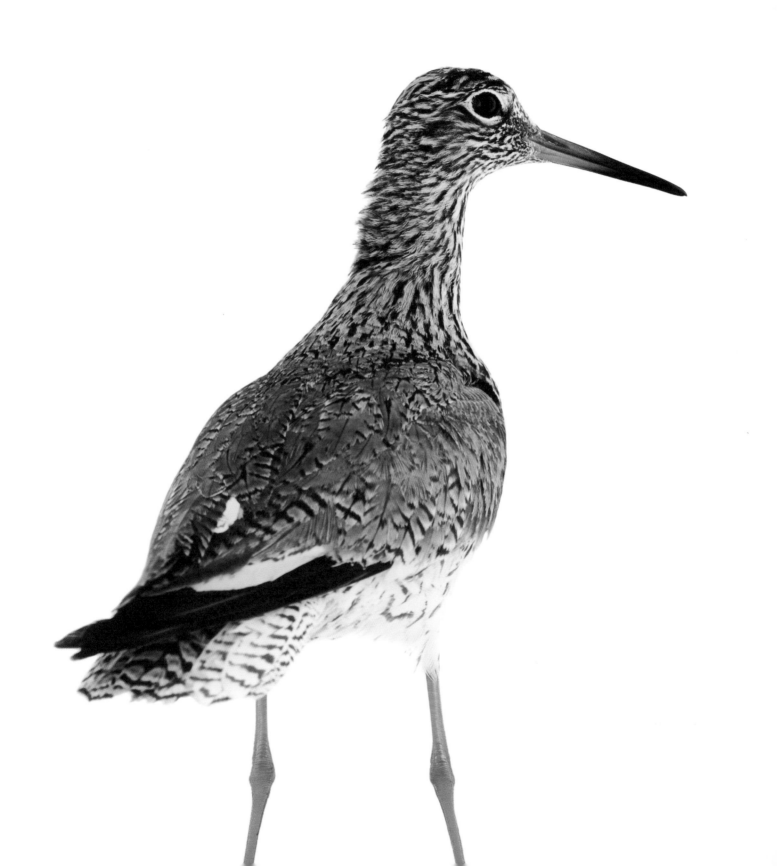

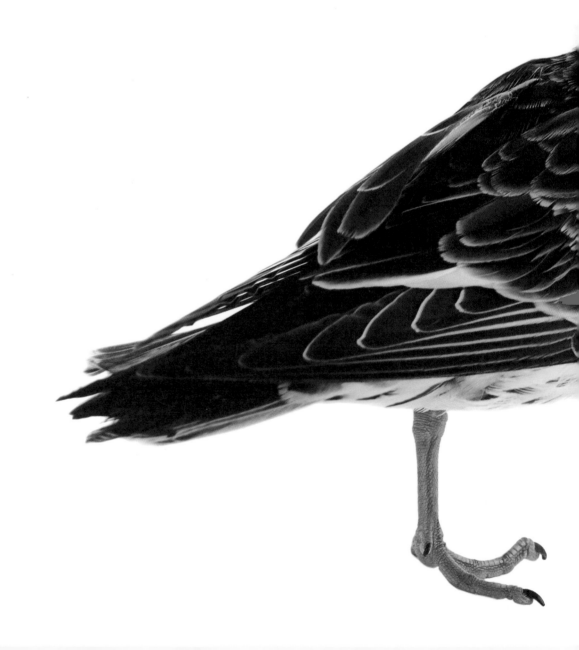

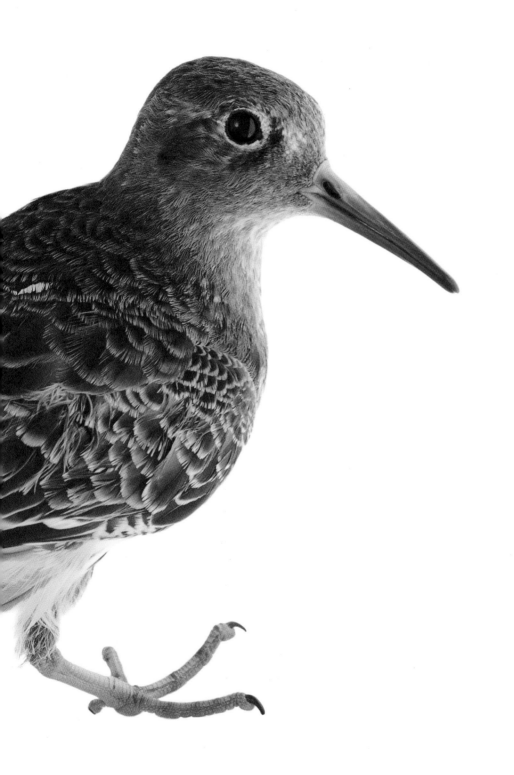

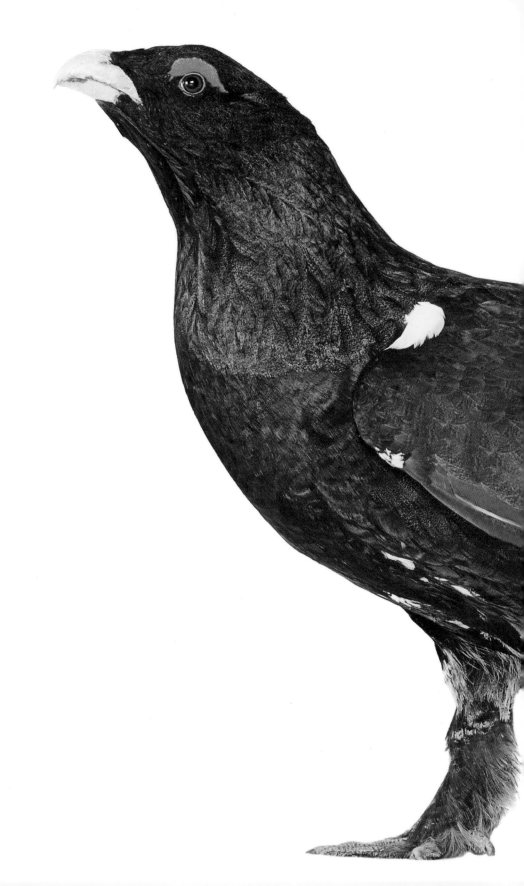

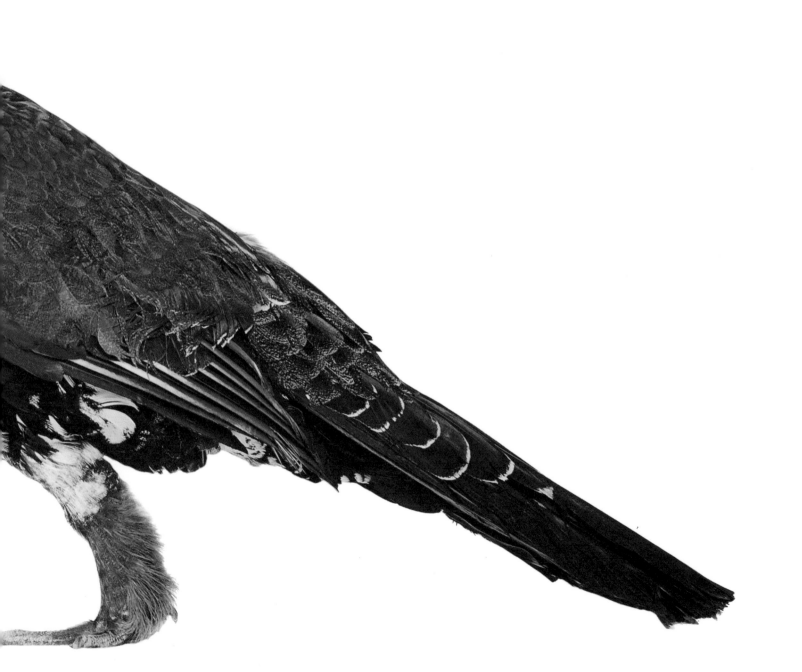

WESTERN CAPERCAILLIE. Eight pounds of pure obsession, with a hook-shaped beak, shiny black long coat, and bulging red eyebrows. Close up, the courting capercaillie cock is magnificent: at once both operatically coquette and almost frighteningly powerful.

No wonder capercaillie mating, or lekking as it can be called, draws such an audience.

But let's look for a moment beyond the spectacle, and direct our attention to what happens afterward, in secretive silence. That which the entire dynamic spectacle of the lek aims toward.

At this point, the extravagant cocks have moved to the background of the story, and the hen is now the main character: the hen, and the blueberry bushes.

The capercaillie's entire life and survival is focused on this plant throughout spring and summer. It begins with blueberry shoots and blueberry flowers, which are the brooding hen's favorite food during the short moments—in total just over half an hour per day—she leaves her nest to eat. When the eggs hatch, butterfly larvae and other insects that live on blueberry leaves comprise the most important food group for the little capercaillie chicks, who can stand on their own from day one. The hen herds them through the forest and keeps the group together using a combination of soothing small talk and sharp warning sounds. But it's up to the chicks to find the food on the blueberry plants, which at first must seem just as tall to them as trees are to us.

As usual, evolution has tended toward the utilitarian. The eggs are timed to hatch when the larvae supply is the biggest. In the best swampy spruce forests, they can be extremely plentiful—researchers have counted up to eight hundred butterfly larvae per three square feet.

A cold spring is troublesome. Not only are there fewer butterfly larvae, but the chicks are not able to feed for as many hours a day, since they must spend more time under the wings of the hen, where they can stay warm and out of the rain.

As the weeks pass, their diet shifts and becomes increasingly vegetarian, dominated in the fall by berries, and once winter hits it's extremely monotonous: spruce needles, spruce needles, spruce needles. Birds are not actually made to feed on things that are so hard to digest, since they don't have teeth for chewing. The capercaillie manages by giving itself a type of internal dentures through swallowing gravel and small rocks. Its stomach is very muscular; the inside has the feel of sandpaper. With this surface and the stones it swallows, nutrition can be squeezed out of the spruce needles and thus the capercaillie survives the harsh and nutrition-poor winter.

During this season, eating is more or less the sole activity for the bird, at least during the few hours a day that the sun is up. At night the birds sleep high up in carefully selected spruce trees. But the stomach is active 24/7, and approximately every ten minutes a new pellet of excrement presents itself, whether the capercaillie is asleep or not. This

usually results in a sizable pile of capercaillie excrement underneath their sleeping trees: evenly thick, slightly bent pellets that look a bit like cheese doodles made from dry needles.

Such excrement piles, found as late winter turns to early spring, make the heart race for fans of capercaillie lekking. It's a sign that you've likely found the sleeping trees in which the cocks wait for dawn and the great showdown over who has the highest status and thereby gets to mate with all the hens.

Anyone who wants to witness the lek knows at this point to prepare a hiding place and bring out the sleeping bag, camera, and snack bag. And a vessel to pee in, because once you're settled in, well before sunset the night before the spectacle, you don't want to be forced to crawl out for a sprinkle that might scare the birds away.

Does it sound a bit uncomfortable? Not enough to stop those who've caught the bug, like Håkan Nunstedt who works as a university department chair. When he isn't in hiding at a lek, that is:

I was no older than thirteen when I first heard the capercaillie cocks' snapping sounds in the great dark forest. It awoke something within me. The anticipation, the mysticism, the unpredictability!

Since then I've kept at it for more than forty years, and my interest doesn't seem to be waning. I've camped out for capercaillie lekking a total of 276 nights. Most of the time nothing happens. You're in hiding, waiting and

listening, and time just disappears. The 271st night something happened that I'd been waiting for during all those years. I came to a site I'd seen on a map but never visited, and I immediately understood that there was great potential for capercaillie lekking here. After I'd spent a few nights in this location and moved my hiding place a few times, I was able to get close to the lek of the dominant cock. There were loads of hens, too. One morning I saw a total of thirty capercaillies, among them seven to eight cocks that were looking to challenge the dominant cock for the hill. I thought I'd seen and heard the most of it, but this was incredible!

I often say that I'm an old-growth forest addict. These experiences and the kicks give quality of life for me. As soon as the season is over, I begin to look forward to next year.

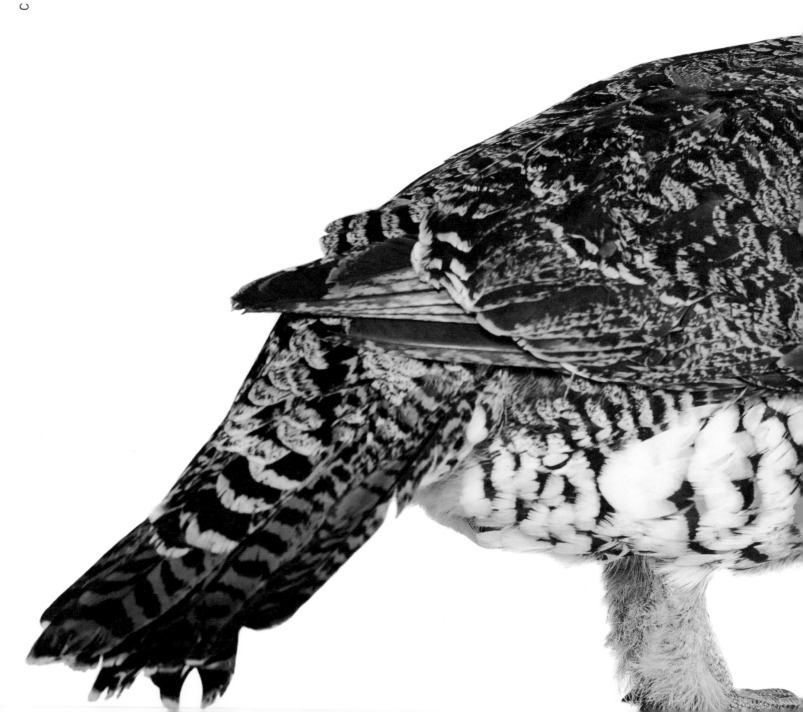

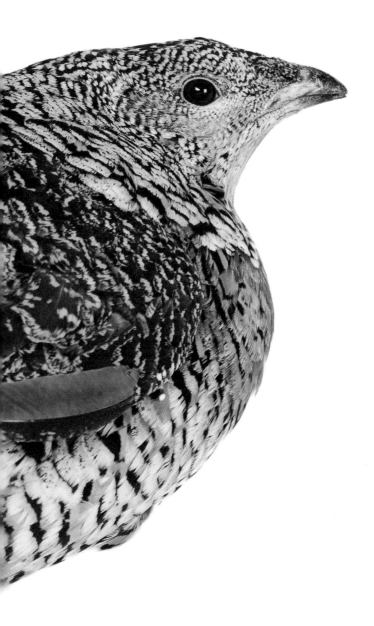

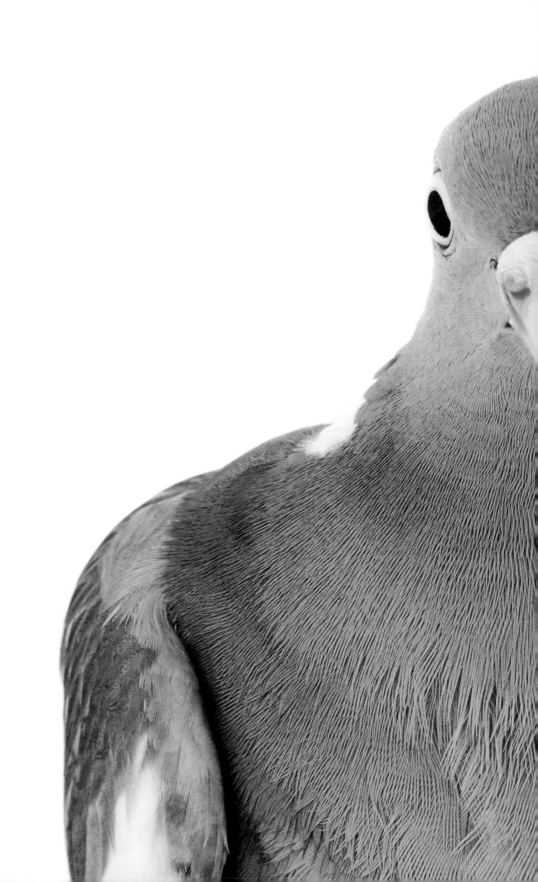

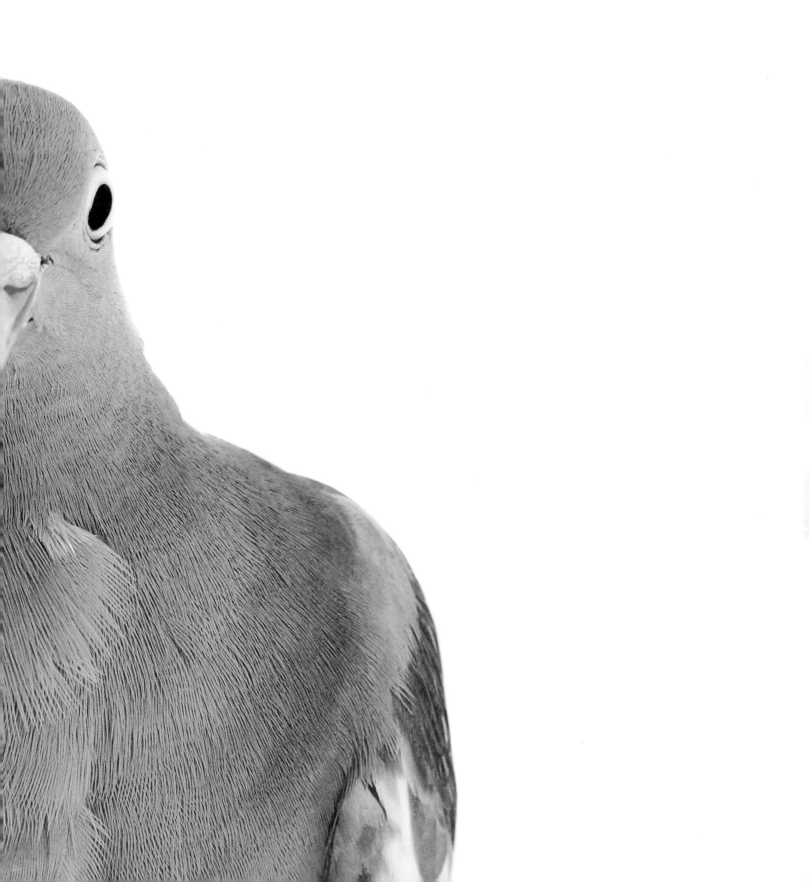

COMMON WOOD PIGEON. We shouldn't judge a book by its cover, but sometimes it's hard not to.

The common wood pigeon is actually a very beautiful bird, with its blush-like, powdery shades that fade from the head's rainy sky gray color to the soft purple-pink of the chest to the earthy gray-brown of the back. But there's something about the proportions, the small head and the large heavy body, that makes it look a little confused. And then there's the asymmetrical pupil, which, as Lars Jonsson points out in *Winter Birds*, gives the common wood pigeon a funny cross-eyed look.

But let's be reasonable. The wood pigeon is neither slow nor funny—it's perfectly shaped to do exactly what wood pigeons need to do. Fly, for example—which it does with great speed, power, and endurance. A marching speed of almost forty miles an hour isn't unusual for a flock of wood pigeons. Their wing strokes are extremely deep and snappy; if you frighten a common wood pigeon during a walk in the forest, its wings make such a loud clattering you'd be forgiven for thinking they might break.

A very particular type of flight show is the exhilarating performance the male gives in the spring to impress the female. He flies sixty to seventy feet skyward until it looks like he's passed an invisible ridge in the air. Then he forcefully brings his wings together a few times—like a short applause—before he falls, tail and wings flared. Even onlookers on the ground can sense the tickle in the pigeon tummy: *eeeeek!*

Robust flight muscles, in other words, contribute to the common wood pigeon's physical constitution.

But muscles aren't the only things hiding behind the swelling pigeon breast. Like many other birds, the common wood pigeon has a crop underneath its chin, a feature of the alimentary tract with the purpose of storing food. For pigeons (and a few other birds, like flamingos and some penguins), the crop has an additional, and very particular, function. When the bird is about to raise chicks, the construction and function of the crop changes, and it begins to produce something called pigeon milk. It's thicker than regular milk and looks more like cottage cheese. In other words, the pigeon crop functions like an internal udder.

The chicks live on pigeon milk, rich in proteins and fats and containing antioxidants and other immune-supporting substances, when they're small. Both parents make pigeon milk, but its production requires so much energy that only small amounts are produced. Wood pigeons almost never lay more than two eggs; with more chicks than that, the offspring would be malnourished.

During the last half century, the wood pigeon has gone from living only in forests and the countryside to taking up residence in the city centers. The feral pigeon (a variety of the rock pigeon) still rules the stone deserts of the cities, but in suburban backyards and parks you can often hear the very characteristic five-syllabic wood pigeon sound: *co coo co, co coo.*

These days, it's a regular feature of the soundtrack of spring, and during the mating season, rivaling males throw themselves from their invisible precipices in the sky above the apartment buildings, applauding themselves. If the performance is well received, it soon becomes time to build a nest, sometimes in spots so close to humans that the wood pigeons of olden days would never have even dreamed to use them. Like the patio of social worker Jeanette Larsen:

One day I found a bunch of sticks on my patio. I removed them, but new ones soon appeared. Then I noticed a few sticks lying across the hook for gardening tools we have on the wall. The next time I came out a pigeon was sitting up there, but it only had two or three sticks to support it. Not exactly a nest. I was concerned and wanted to help by putting up some chicken wire, but thankfully I never got to it because it wasn't long before the pigeons had made a proper nest. After that there was always one pigeon brooding. They took turns. It made me really excited, and I joined the Facebook group "Birds on the Corner" to learn what type of pigeon we had at ours. It was a wood pigeon.

My daughter and I felt quite privileged that they had chosen our patio for their nest. They have two chicks now. My friends are not very impressed; they mostly talk about how much pigeons poop. We don't care. I'll just clean that up once they've moved.

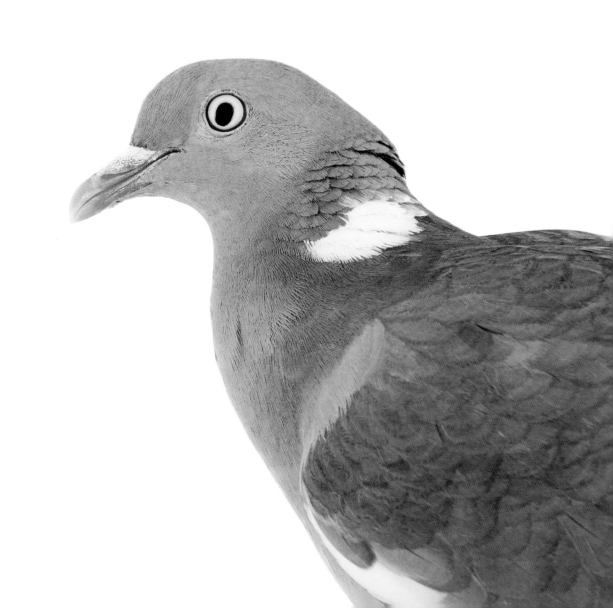

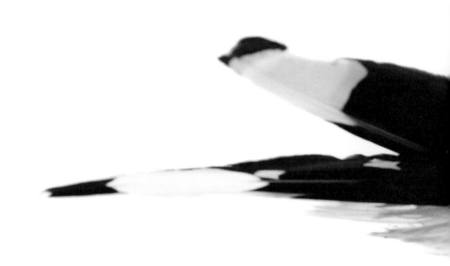

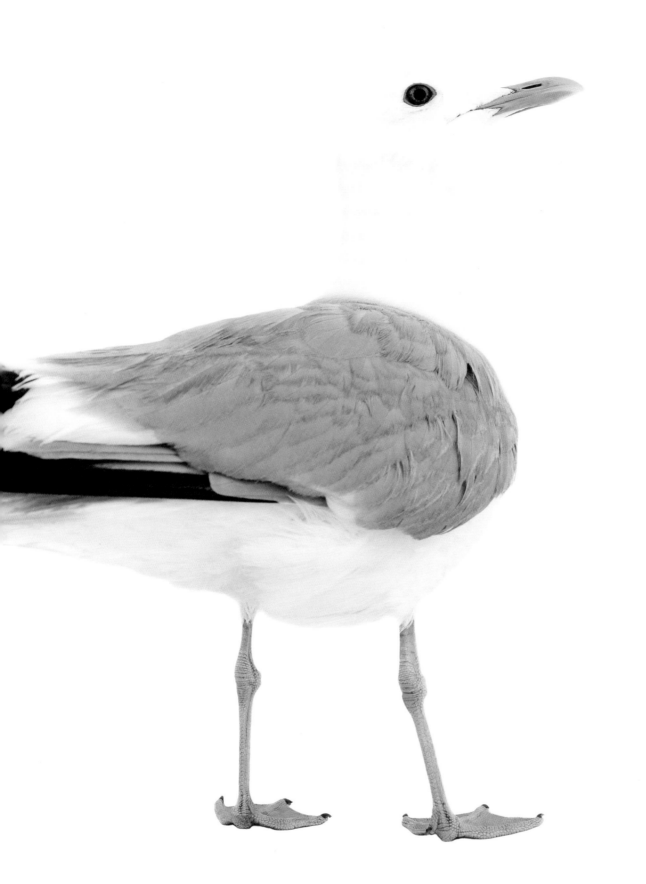

COMMON GULL. Three: the standard number of eggs in the nest of the common gull. But it happens every now and then that a nest has double that number. In almost every case, it's because two female gulls have combined their clutches. Such same-sex couples are relatively common for a few gull species outside of Europe—one in New Zealand and one on the West Coast. The generally accepted explanation is that this arrangement occurs when there's a shortage of males. Female-only couples tend to have less food for their chicks and a smaller number of them reach adult age— it's obviously more difficult for two parents to raise six babies than three. But fewer chicks per female is a better outcome than no chicks at all.

Gulls are prone to socializing and like to brood in colonies numbering up to ten couples. But they can also be seen brooding solo every now and then. The classic image of a gull might be a nest on a rock outcropping or some other small rock in the water. The bird isn't particularly bound by tradition, however, and you can find nests both in trees and on roofs. The latter is increasingly common as gulls are finding their way to cities.

Having a gull brood outside your window can get annoying—its piercing cries can hardly be called beautiful. But in other contexts, they are deeply, passionately loved, even by people who wouldn't be able to define the sound they're hearing as the call of a gull. Thanks to its ubiquitous presence on lake and ocean beaches, the gull's cries are the soundtrack to summer vacations, immediately bringing to mind relaxing days on docks and beaches.

When you see the bird against the sky you can guess why gulls and terns are mostly white, especially on the underside. They spend their time hunting small fish and other creatures that swim right beneath the water surface, and the brighter the underside, the more invisible the bird is when it dives like a projectile from above. The white color of the gull is a type of camouflage, a method for resembling the sky, like light itself.

It's also believed that the white color functions as a useful signal in the birds' internal communication. When a flock of gulls begins to tumble around in their characteristically tumultuous way above a bountiful school of fish or in the wake of a boat, they're visible from very far away. The white gulls turn into maritime flags: *food*! It's not long before more gulls and terns arrive to join the feast.

But it would be incorrect to suggest that the gull feeds exclusively on fish. The bird is just as likely to be looking for food on land: worms that have emerged in the tilled soil behind the farmer's plow, insects in newly cut grass. Like many other gulls and terns, the common gull has a clever method for attacking mussels. It's unable to open the strong, hard shell of the mollusk, but just like humans, it knows to compensate its physical shortcomings with wits. The gull will grab the mussel with its beak, fly thirty feet or more into the sky, and drop it onto a rock, a stone dock, or another hard surface, crushing the shell so that the soft animal inside is exposed.

The gull, just like its larger relative the herring gull, is also partial to humans—or, rather, to humans as potential suppliers of all things edible. Financial assistant Ingela Durakovic learned this when she made Olle's acquaintance five years ago:

We were grilling out at our house near the sea when a gull suddenly landed next to the table. We thought he was sick or injured and gave him a mushroom, which he gobbled up. Since then he's returned every year. The lady next door is really enamored with him and she's named him Olle.

Olle often shows up when we're leaving for work; he'll stand beneath the porch, looking at us and hoping for something to eat. At first we'd give him meatballs, and later we tried cat food. He liked that. My husband and father-in-law often catch common roach when they go fishing, and they give it to him. But we never put out food when he isn't there.

His wife appears later in the season. She's a little shy in the beginning, but gets braver with time. They beg for food, splash and drink in our birdbath, or pick insects from the lawn. They're friendly and surprisingly quiet; it's only when other gulls fly by that they cry out.

In July all the gulls leave—Olle too. It gets totally silent here.

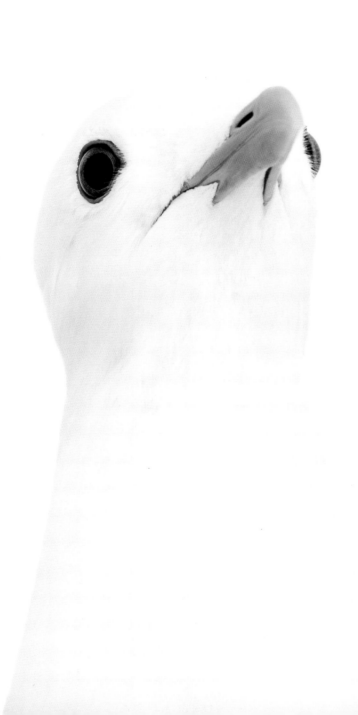

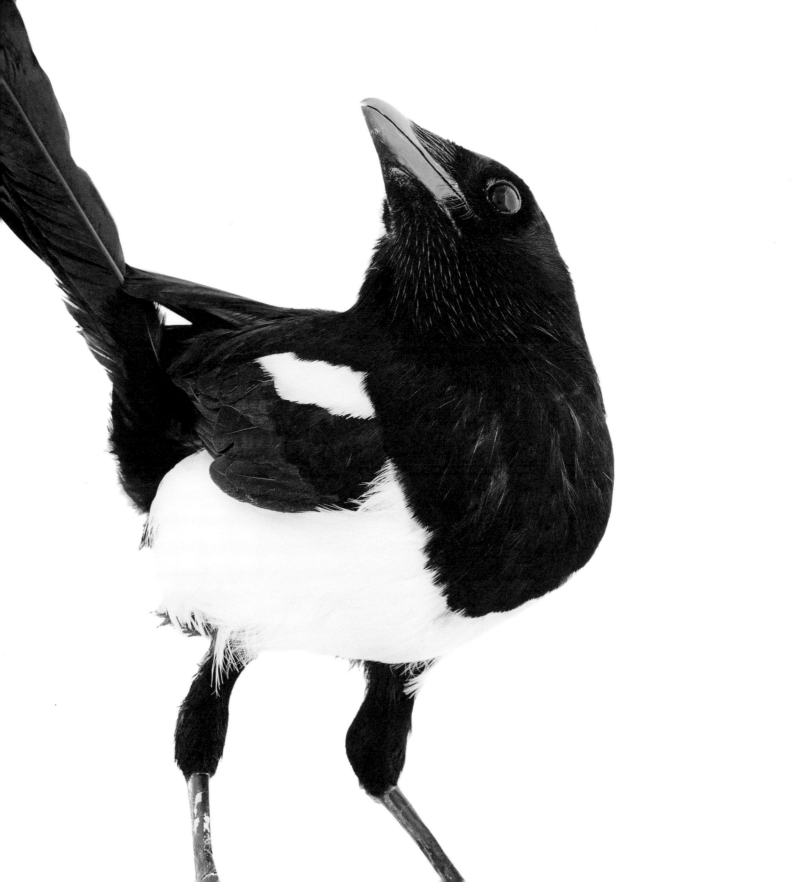

EURASIAN MAGPIE. In Swedish, a messy hairdo is called a *skatbo*, a magpie nest. This is a rude characterization, not least on behalf of the magpie. Its nest might look a little unkempt, but it's been fashioned with great care and skill to form a perfect globe with a well-hidden opening on one side. The couple collaborates on the construction, with the male bringing carefully chosen twigs and the female assembling them. Sometimes preparations begin as early as November, but the more goal-oriented construction starts at some point in February or March. A magpie nest takes on average three weeks to build, but it can be anything from one to eight weeks depending on the couple's level of experience and how easily they're able to find appropriate materials.

At the base of their cave of twigs they make a bowl from clay soil and insulate it with moss, grass, and other soft materials. This is where the female magpie lays her eggs.

Anyone who's ever peeked inside a magpie nest knows that she's pretty comfortable in there—her home is spacious, but still cozy. It's the perfect treehouse, the kind that all children, young and old, dream of hiding away in, swinging in the wind.

The human-magpie relationship is mutually ambivalent. A love-hate relationship, one might say.

For humans across the vast areas where the bird makes its home, the magpie has been a character in myths, fables, and figures of speech

throughout history. Whether it's viewed as a bringer of luck or misfortune depends entirely on place and context.

It's incontestably beautiful, though poet Joar Tiberg sneaks in an "actually" in his poem about the magpie—that ambivalence, again. He describes the magpie as "actually incredibly beautiful," with feathers that appear to be black but shimmer blue-green and red.

The incessant shimmer is the sunlight creating iridescence in the feathers' surface structure. Upon finding a freshly molted feather, you'll easily find yourself transfixed, twirling it back and forth to see the sun fall on it from new angles. The feather keeps changing its color. Change might not be the right word, in fact; the black foundation remains, but other colors play on top of it like mirages.

As for the magpie itself, it's a bird of culture. That is, it desires our proximity and knows how to take advantage of it. At the same time, it knows humans too well to trust them. Despite its closeness to us it retains something wild and feral, something that could be defined as integrity. Tiberg writes that you might have lived alongside a magpie for many years, but the bird could still be a mystery to you.

It often feels like the magpie watches us just as much as we watch it—perhaps even more so! And there's no doubt that the bird intellect inside that black hood is unusually sharp. One example is the five magpies at Goethe University in Frankfurt, who ten years ago shocked the world by showing that they understood, looking into a mirror, that they

were seeing themselves. This is an ability generally only found in some mammals like certain monkeys, elephants, and dolphins (and humans of more than eighteen months).

The sharp wit is linked, among other things, to the bird's flexible eating habits. A majority of the animals we consider particularly intelligent are omnivores, and this is also true for the magpie, which happily eats frogs, beetles, berries, worms, chicks, and all kinds of leftovers. It likes to hide pieces of food for future needs (but usually empties its inventories within a few days). The stubborn belief that magpies steal shiny metal objects and hide them in their nest, however, has been questioned. A few years ago, a British experiment presented magpies with two piles: one with nuts and the other with shimmering metal objects. The birds went for the nuts in sixty-two out of sixty-four cases, and when they picked a metal object, they would immediately drop it. So, the larcenous character of the magpie appears to be strongly exaggerated, at least as it concerns silver spoons.

But you can never be too sure with magpies. Kindergarten teacher Anne-Lie Rosenqvist has found that there are a few things her local magpie couple absolutely cannot resist:

I don't know if it's the candle wax or the shiny aluminum they want, but the magpies that live in the big willow tree outside our kindergarten always steal the tea lights we use to make snowball sculptures with the kids.

Our magpie couple has been here for several years now. We've tried to get rid of them by tearing down their nest, but we can hardly take it down before they build a new one. You could say the victory is theirs.

Every year they have two or three chicks. The family life of the birds goes on right above the kids. Last year we found all the baby birds dead in the sandbox. We buried them in the hill by the oak trees nearby. This year's family also experienced some drama when three falcons flew around the willow tree, attacking the nest. The magpie parents were making a great ruckus defending their chicks—that's how we realized something was going on. The falcons gave up and left soon enough, and all was quiet again. Later that day the magpie chicks were sitting on our green wire fence, being fed by their parents. They had all survived.

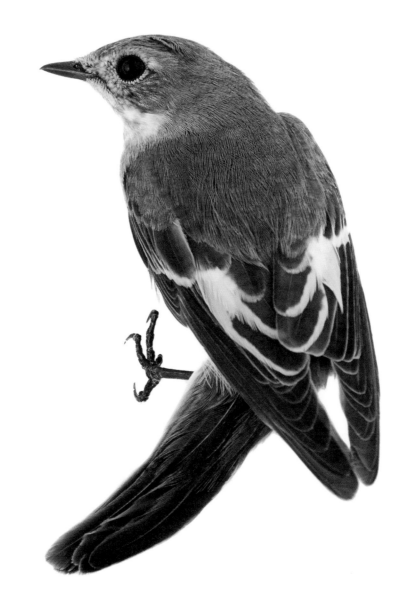

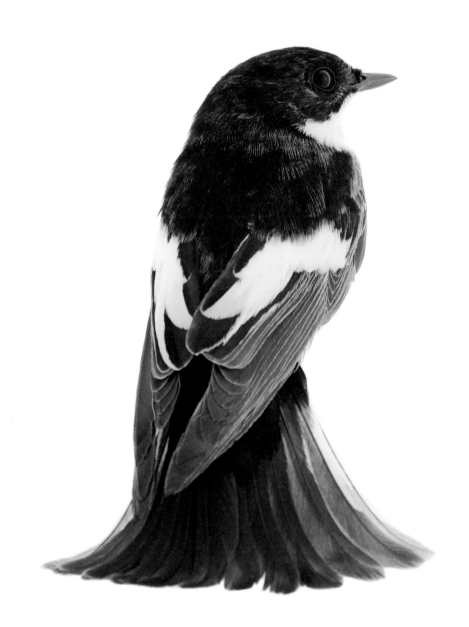

EUROPEAN PIED FLYCATCHER. Size actually does matter. Scientists at Uppsala University have determined this, at least when it comes to the size of the white forehead patches on the European pied flycatcher male.

Using typewriter correction fluid and black hair dye, the scientists changed the shape and size of the white patches and observed how this affected the males' sex appeal. The results were clear. The bigger the patches, the more attractive the male. Somehow, the patches function as a signal telling the female about the male's quality as a partner: that he's strong and healthy and able to deliver good-quality genes.

At least this was the case a few decades ago. It's possible that the females have changed preferences since then, because that happened with the almost-identical collared flycatcher species, according to a recent study. Something—possibly the warming climate—has affected their preferences such that they now appear to prefer males with small forehead patches.

Regardless of forehead-patch size, these research results are a reminder that the flycatcher has become a favorite among scientists of evolutionary biology. And the favoritism has rubbed off on the bird's image. It's rare to read an account of flycatchers that isn't dominated by a discussion about why one partner acts this way or the other in order to reach maximum procreative success.

This isn't because of unusually crass relationships between the flycatcher sexes—in fact all species have such relations if you consider

them from a certain angle. It's just that the European pied flycatcher has been the object of particularly keen scientific inquiries.

It all started in 1979, when the abovementioned scientists requested four hundred flycatcher-sized nestboxes from their university carpenter. They focused on the flycatcher because the species likes to live in nest-boxes and are comparatively easy to catch, band, study, and subject to various types of experiments.

It turned out that polygamy is more or less the rule for male flycatch-ers. Once the male has sung to proclaim his territory in the spring, once he's demonstrated a few possible alternative homes for a prospective female and won her yes, he moves on to a new territory, which can be located anywhere from some hundred feet to several miles away. If he's lucky, he succeeds in wooing a female to mate with there as well. There-after he tends to return to the first female, with whom he splits the labor of raising the brood. It's rare that female number two receives any help in securing the survival of her chicks.

The motivating force behind this behavior is evolutionary, aimed to give the individual the largest success in passing on his genes. A polyg-amous male gets on average 8.05 fledged chicks per season, whereas a monogamous individual only gets 5.49.

But other factors complicate the math. It was discovered that female flycatchers often mate in secret with males other than the one they share territory with. The male might thus be delivering food to a brood with a different father, and the equation changes since his procreative success

is actually smaller. The female, on the other hand, might win out. Especially if male number two is genetically a better catch.

So, there you have it, on its special branch of the tree of knowledge for evolutionary biology, the European pied flycatcher symbolizes how everyone prioritizes their own procreative success above all. But it represents something very different as well. For many humans, probably including evolutionary biologists, this bird is among the most important and strongly felt signs of spring. Once the male European pied flycatcher arrives, around the time all trees have new leaves and always a week earlier than the female, spring feelings explode in intensity for most of us, regardless of the way he handles his marital relations.

The flycatcher's fondness for bird boxes is not just a boon for researchers—it also means that anyone with a backyard has a good chance of getting this spring herald as a close neighbor.

If you, like retired social services administrator Gunilla Teckenberg, have a garden large enough to fit seventy bird boxes, you might be blessed with not just a couple of flycatchers, but four or five in a year.

These little creatures aren't just beautiful; they're also super tough. They have to be, because by the time they show up in our backyard a lot of the nestboxes are already taken. Sometimes we save a few to put up right before the flycatchers come. When it's time to mate, they really raise their voices to win the

prettiest lady. There's an unbelievable chattering here during that time, and the rivalry is intense among the flycatchers. Sometimes one male will battle another male for a specific nestbox even if there is a free spot somewhere else.

I have an emotional bond to all living things and feel for each and every little being. The flycatcher is no bigger than the palm of my hand, but every year it flies all the way from Africa and lands in my backyard on the first of May. It demands respect. This bird really touches something deep within me. I wonder how climate change, desertification, and other environmental problems are going to affect the long-distance migrating flycatcher? How will this little bird fare in the future? I think about that.

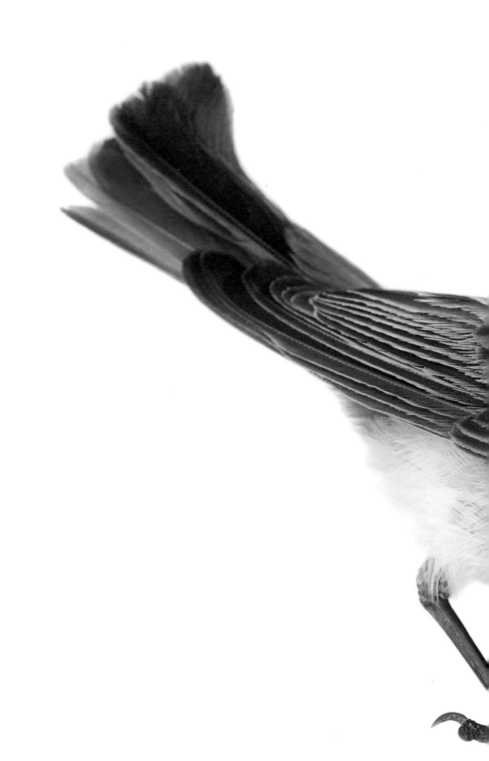

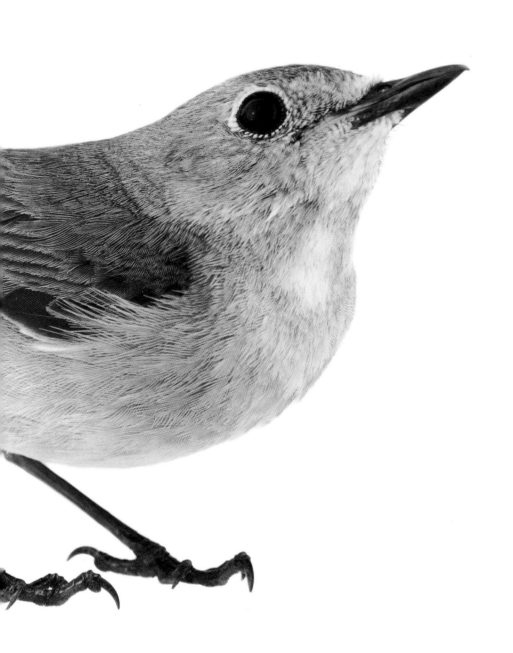

COMMON REDSTART. No matter where you find it, the redstart tends to be fairly withdrawn. European pied flycatchers, starlings, and great tits are more well-known to gardeners since they expose themselves to a much greater degree than the redstart, which only emerges in short glimpses. You'll spot it on a tree branch for a few seconds, its brick-red tail shivering in that characteristic way. And suddenly it's gone. But the reverberations are strong: "the redtail is brighter than usual when he takes off, like a small firework that stays on the cornea for a moment after he's gone!" wrote Erik Rosenberg.

Humans may often miss the redstart, but the cuckoo certainly won't. The notorious brood parasite, which lays its eggs in other birds' nests and delegates the feeding of its chicks to surrogate parents, has varying preferences across Europe. In Scandinavia, the redstart is one of its regular victims, and it appears to be especially beset in Finland. A cadre of female cuckoos specialize in laying their eggs in redstart nests, and these eggs are often bright blue—identical to those of the redstart. (Conversely, there are cuckoos whose eggs are mottled on a white background and laid in white wagtail nests, and others whose eggs have big spots on a blue-green background and are laid in reed warbler nests; all to maximize the trickster's success.)

Finnish scientists have shown that about a third of all redstart nests are visited by egg-laying cuckoos. But a cuckoo visit doesn't mean game

over for the redstarts' own offspring. Contrary to most other birds victimized by the cuckoo, the redstart builds its nests in holes in trees and similar spots, and this complicates the aim of the brood parasite. Her egg often falls on the edge of the nest or even on the ground beneath it. But if she aims well and puts her blue egg among the blue eggs of the redstart couple, it's almost always accepted.

But what about the rest of us, those of us who lack the female cuckoo's sharp eye for the redstart? What are we going to do? Use our ears, perhaps. The way to a close redstart relationship is through the ears, both because you tend to hear the bird more often than you see it and because the song is a special thing to hear. It might be the most underrated song of Scandinavian birdlife. The verses are simple and a bit nostalgic, separated by fairly long, artful pauses. The impression is enhanced by the song's performance from up high, which makes the sound carry far, and its early morning timing. Often, it can be heard before morning has even broken.

For hotel host Cecilia Lundin, the song of the redstart symbolizes more than anything the freedom of walking on dry ground after a very long winter:

Before the tourist season starts, around May 20 when there's still snow in the ravines, my friend and I like to go to the waterfall. During these hikes, we always hear the redstart. To me, it's a real forest bird.

My strongest redstart memory is from my timbered cottage outside of town. I've put up several bird boxes, but the redstart tends to pick the most dilapidated one just a few feet from the house. It was one of the first days of summer, and the weather was glorious. A friend came by and we ended up on the porch for a long time, watching the redstart female feed her chicks. Sadly, a pied flycatcher came two weeks later and expelled the redstart family. But we didn't know that then. She was so beautiful; with a nestbox you can see the red tail very well. It's a close encounter.

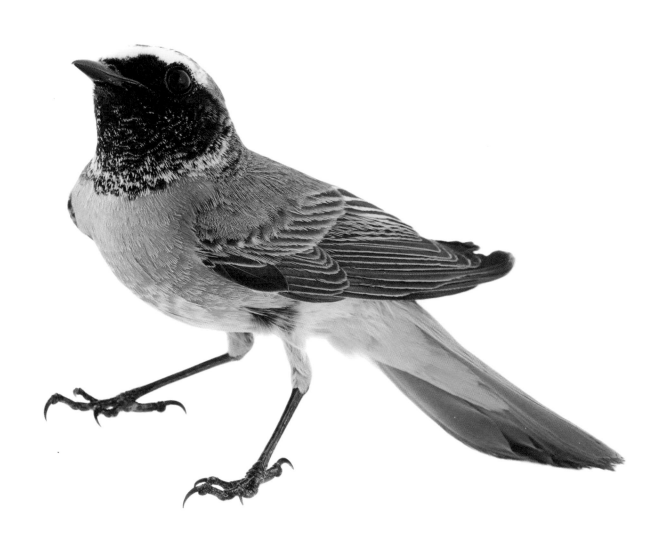

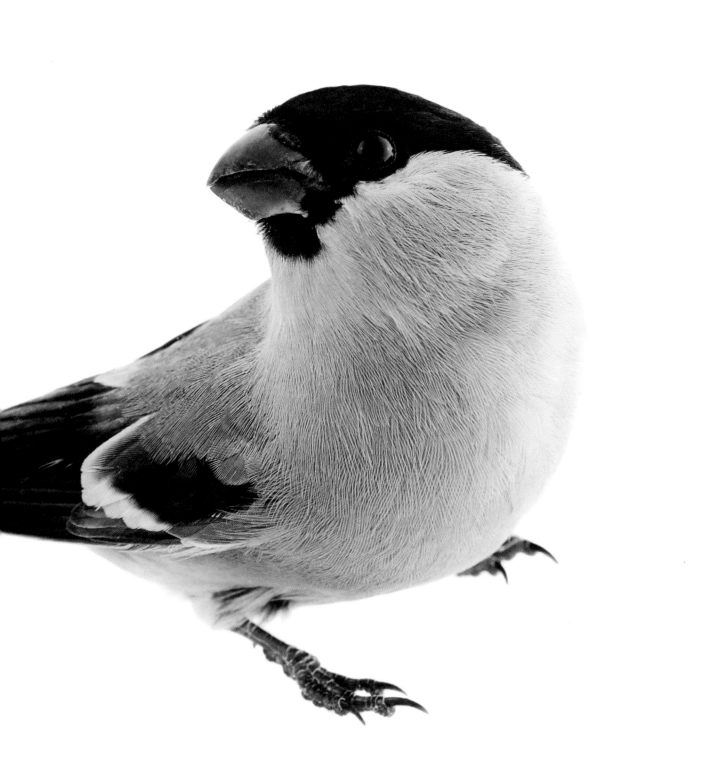

EURASIAN BULLFINCH. "Golden Evening Sun" and "A Hunter in Kurpfaltz" are the titles of two German songs recorded on a CD published by the British Library's sound archive. The artist is a domesticated bullfinch, a bird that was trained by a Mr. Chr. Grösch, in the German state of Hesse. The recording was made as recently as 1968.

The real glory days for whistling musical bullfinches were in the nineteenth century. It was widely accepted that the best ones came from Germany, and the epicenter of the production was the state of Hesse. The process began by young boys plucking bullfinch chicks from their nests at a point when the latter were approximately ten days old. The chicks were soothed to make them calm and obedient, and before long the training started, entailing the playing of a select melody again and again, morning, day, and night, ideally in conjunction with feeding. In some of the bigger training centers, the birds were kept together in groups of six birds each. Once they made some progress with their singing, the birds were split up and given private education by young boys tasked with playing the same music piece again and again on a so-called bird organ or a flageolet intended specifically for bird training.

Great numbers of trained Eurasian bullfinches were exported to countries like England, Holland, and the United States. The songs of these traveling birds were different, for example "God Save the Queen" or "Yankee Doodle Dandy." One single bird vendor, Mr. Thie in Waltershausen, Germany, delivered one to two hundred trained

bullfinches a year to customers in London and Berlin. The birds had many fans, especially among the ladies. The bullfinch is not just calm and easy to train, it is also "a very beautiful bird, notwithstanding that he is somewhat thick in proportion to his length," as it is described in *The Friendship of Birds* from 1877.

Today bullfinches are spared from cages and the on-demand performance of German folk songs and British hymns. The species has been given a wholly different role in our culture: it's become the Christmas symbol above all others.

A prerequisite for the bullfinch to even be considered for this part is the drastic personality change it undergoes when the year grows dark and cold. The wild-bird shyness that characterized it during the brooding season is gone with the wind, and suddenly bullfinches arrive in gardens and at bird feeders, turning into birds who live in close quarters with humans. Sometimes you also see them against a snowy background, a requirement for the real Christmas feel. A bullfinch without snow is like a Santa in a tracksuit—it's just not very real, as the watercolor painter Lars Jonsson has put it.

Naturally, the male steals most of the attention. But do take a look at the female the next time you get a chance. The colors of her plumage bring to mind high-class design. She looks expensive. Jonsson, a master of capturing the birds' plumage with both brush and words, has

a particular love for the sober dress of the female. "The beige-brown pastel shades of her stomach bring to mind a palette of warm brown lipsticks or eye shadows, or perhaps it's blush I'm thinking of?" he writes in *Winter Birds*.

But if we were to hold a popular vote about the attractiveness of the bullfinch, the male would win hands down (and the closer to Christmas, the bigger his victory). Population registry administrator Anna Berg is one of many who find themselves drawn to the bright red of the male's chest:

It always makes me so happy to see a bullfinch. The bird's robust figure and its tough attitude appeal to me. My whole life, it's been a mascot for me. When I was browsing Christmas decorations on an auction website a couple of years ago, I found a big wall hanging with embroidered bullfinches. That one has my name on it! I thought. The craftsmanship is gorgeous.

My love for small birds stems from my grandmother, who always liked them a lot. Her love spread through the generations: my mom, my sisters, and my daughter—they all love small birds. Grandma also liked embroidery, so the wall hanging reminds me of her in many ways. It speaks to my heart.

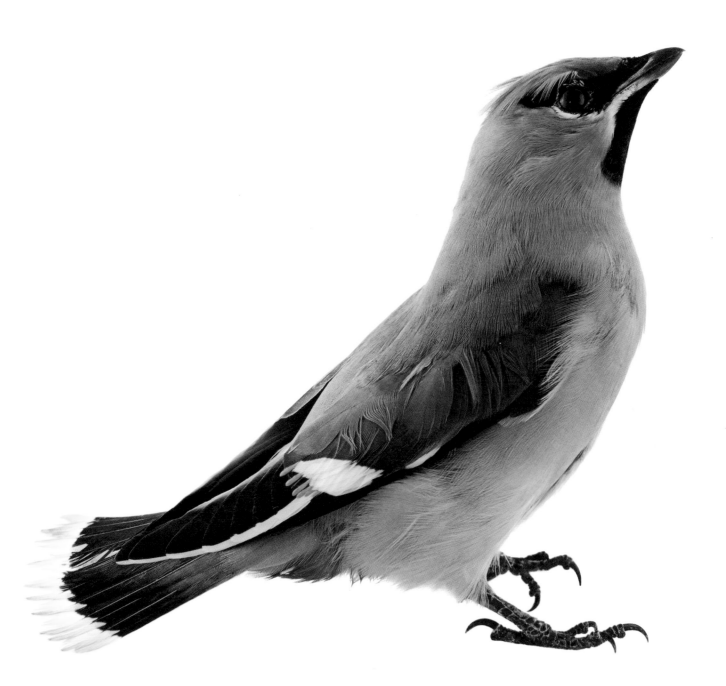

BOHEMIAN WAXWING. In the summer, the Bohemian waxwing is reclusive, catching insects for its chicks using flycatcher-like acrobatics in the remote coniferous forests of the north. But in the fall, the Bohemian waxwing is eye-catching, moving south in big flocks.

It usually begins with the sound of a sharp trill from somewhere above. If you already know that this sound means Bohemian waxwing, you'll know to look for their characteristic silhouettes in the treetops or the glimpse of figures quickly passing through the sky, strongly resembling a flock of starlings.

And you will want to see them. You'll want to feel the waxwing happiness fill your body. You might even find it difficult to keep from laughing if you get close enough, since its look is a bit crazy: that combination of the cocky beak, the eyes that look like the bird went a little overboard while putting on makeup in the morning, and that tuft of hair at the back of its head that gives it the impression of wearing a ball cap turned the wrong way or an unwieldy slicked-back hairstyle.

During fall and winter, the waxwing feeds on fruits and berries that are no longer entirely fresh. This puts the bird at risk of intoxication, since the sugar in these foods tends to ferment and turn into alcohol.

But evolution is a fixer. As the species began to eat fruit, it also developed an unusually large liver (sometimes as big as a tenth of the bird's body weight) and an improved ability to break down alcohol.

But it can still get to be too much of the good life. In the late fall of 2011, Swedish media reported that a person had contacted the police about a bird behaving suspiciously. The caller believed it was a cockatiel that didn't know how to fly, and the police referred the issue to a pet store. Here, it was established that the bird was a drunk Bohemian waxwing. The bird was released once it had sobered up.

This doesn't happen only in Sweden. *National Geographic* wrote about a similar incident in Canada's Yukon province, where a number of waxwings had to be put in drunk tanks—actually modified hamster cages— at the regional veterinary ER after having gorged themselves on alcoholic rowanberries.

The Bohemian waxwing is one of the most typical so-called irruption birds. They don't, as other birds, commute back and forth to a specific winter residence. Their movements are much more irregular and unpredictable. Some winters you might see no waxwings at all, and other years they are everywhere. Sometimes the irruption lasts for a year or two; other years they stay for weeks. It's contingent on the supply of fruits and berries: whitebeam berries, juniper berries, apples, and others. Letting their stomachs guide them, the birds move southward through Sweden, region by region. With plenty of food the migration is slower, and if there's less of it, the birds go fast. Some years their journeys can take them far—it all depends on how much food there is. Bee Thalin,

a photographer with a particular interest in capturing the birds close to her, has been able to establish this from her own experience:

I hadn't seen them in four years when an acquaintance in a birding club called me to say there were waxwings in a tree about a mile away. I immediately scattered some apples and rowanberries around my feeding table. I'd picked the berries the previous fall and saved them in my freezer. It didn't take more than an hour for the waxwings to come. I saw in the corner of my eye the first one flying past the window, and a big flock followed. I ran to get my camera.

The closest I've been to them is one and a half feet. They recognize me; we've gotten to know each other. When I'm looking at and photographing waxwings and other birds, I feel like I can sit there forever. It's peaceful, like meditating.

Waxwings are beautiful and slightly cheeky. They're hilarious. I like their personality—they seem temperamental and squabble with each other, but they're still fair. When they sit in the trees, they talk a lot, gurgling, singing, trilling, and communicating.

Then a goshawk comes, and, BAM! every waxwing is gone.

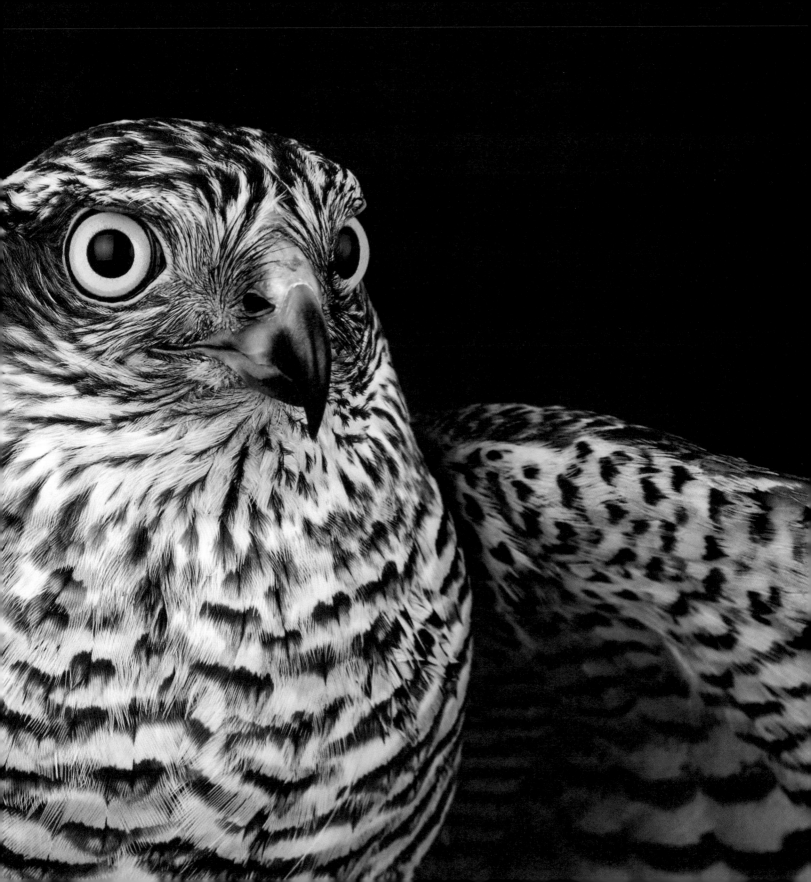

EURASIAN SPARROWHAWK. You feel lucky not to be a tit when you look into the eyes of the sparrowhawk. It's easy to imagine the fear that any small bird must feel before those orange irises. That's what death looks like to a great tit and common chaffinch.

Thankfully we're human and can safely marvel over the intensity in the sparrowhawk's gaze.

People who keep a bird-feeding table outside their kitchen window have the greatest chance of seeing those eyes, at least for a few seconds. Crassly put, "bird-feeding" takes on a double meaning here. If you feed small birds, you're also arranging a buffet for sparrowhawks. The Eurasian sparrowhawk has no qualms about hunting in the cities, and it only makes sense that it pays full attention to the gathering of smaller birds served up by humans.

The hawk makes its reconnaissance from a distance, and when it's time, it accelerates through a steep dive, flattening out once it's close to the ground. The predator plans the attack so its approach is hidden until it rounds the last corner or skims the last rooftop.

Once it's revealed itself, all alarms sound. Suddenly every little bird speaks the same language. Sharp warning sounds are legible across species lines. If a tit screams *hawk!*, the sparrow knows exactly what it means and flees for its life.

The male Eurasian sparrowhawk specializes in tits, sparrows, and other tiny birds. The female goes after thrushes and at times even pigeons.

The divergence in their selection of prey is a result of the female being slightly bigger than her partner.

We often consider large males and smaller females the standard because that's the relationship in our species, but among birds of prey for instance, the opposite tends to be true. This is particularly pronounced in sparrowhawks and other predatory birds that live off hunting fast, sneaky small birds. The female sparrowhawk can be almost twice as heavy as the male. With species that hunt mice and voles, the difference is not at all as big.

Many theories have been put forth to explain the difference, but none have been widely accepted. We simply don't know why it is this way.

Since most of us stop feeding birds when winter is over, sparrowhawk observations tend to thin out with spring. But for small birds, the hawk remains the bane of their existence. The danger is biggest around the time their chicks fledge and begin to explore the world on their own wings. The brooding of the hawk is synchronized with the brooding of its prey in order to secure access to enough food for the hawk chicks. Between thirteen and twenty-eight pounds of quarry is needed to bring up one brood of sparrowhawk chicks. To reach that number, the male must catch about ten small birds every day to give to the female and their chicks.

Does it sound cruel? It is no stranger than swallows brooding in the summertime when it's easier to find insects to feed the chicks or the

crossbill brooding in late winter when there's more availability of pine and spruce seeds.

After all, sparrowhawks are also entitled to live, as Helena Heyman, retired physiotherapist and biologist, put it when describing the time she came across a female sparrowhawk feasting on a rock dove in her backyard. That was far from her only close hawk encounter:

One cold and windy February morning I was up on my roof. I was wearing my warmest coat, the one with a fur-trimmed hood. I'd climbed up there to drink my morning tea and watch the birds. On my neighbor's roof was a sparrowhawk who seemed to be looking my way. It moved closer, so close that I could see its yellow stare. The next thing I knew, the bird was in the air, flying straight at my face. I threw myself down to escape the attack and the bird turned and flew across the street before it disappeared behind the roof of the church. It probably thought the fur trim of my jacket was a potential prey. Talk about a close encounter!

Another time I was driving slowly on a bad forest road when I saw water cascading from the deep wheel tracks ahead of me. First I thought it was a hen poking around, but then I saw the bright yellow, long legs, like knitting needles. It was a bathing sparrowhawk! It had a soft gaze and seemed delighted. After a while it was soaking wet and looked pretty shabby. For a second I thought something was wrong with it, but then it took off and flew straight to the top of a birch tree and sat there, drying in the morning sun.

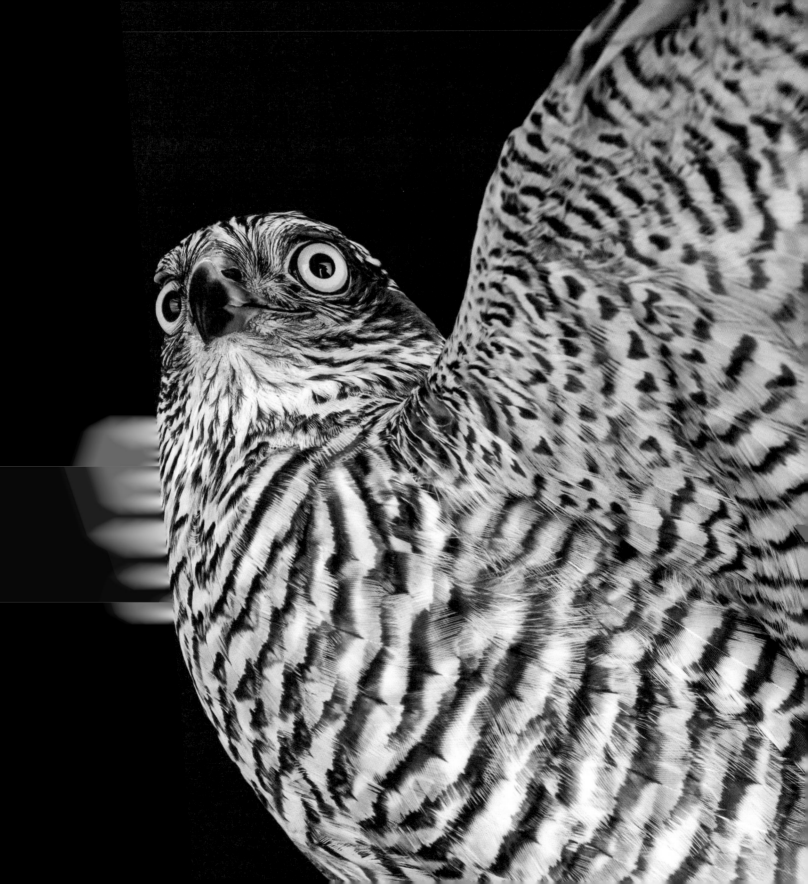

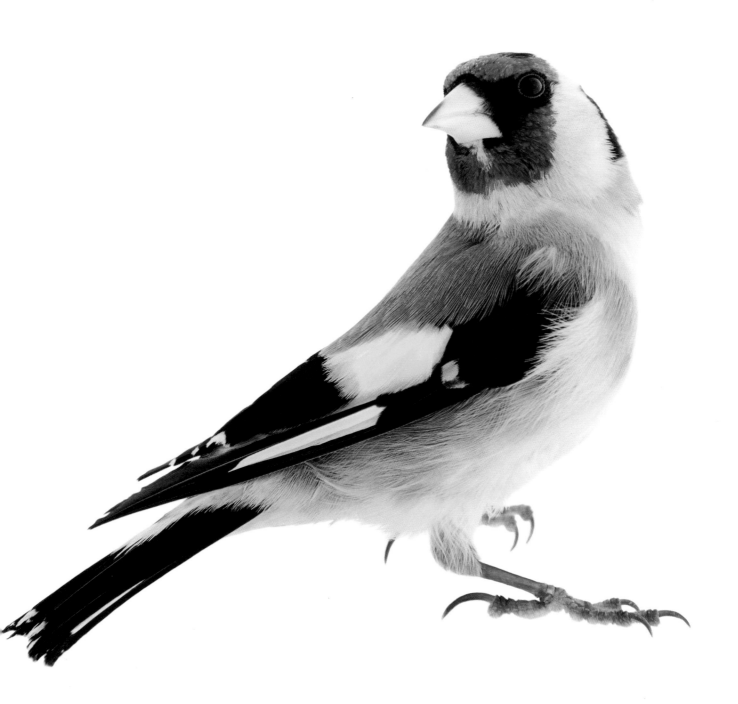

EUROPEAN GOLDFINCH. It has its own cultural biotope: Medieval and Renaissance paintings of the Madonna and Child. They frequently feature a goldfinch, often sitting on a finger of the Madonna or on baby Jesus's hand.

In hindsight, it looks pretty strange—why a goldfinch?—but for centuries, the bird was a common symbol for soul and sacrifice, death and resurrection. An ornithologist with an interest in the arts once counted all the known works that include goldfinches in a symbolic role and arrived at five hundred.

2
3
2
—
2
3
3

The most famous of all goldfinch paintings was not made in the Renaissance, however. Nor does it feature a religious motif. The painter is the Dutch seventeenth-century artist Carel Fabritius. It's a small work, about the size of a legal pad, and simple: it depicts a goldfinch perched on a small seed box on the wall, shackled by a thin metal chain.

Fabritius died in a freak accident in 1654, the year he made this painting, when a gunpowder factory near his home exploded. Only a dozen of his paintings survived, and for two hundred years he was forgotten, before being rediscovered and claimed as one of the big Dutch painters after Rembrandt and Vermeer. The masterful goldfinch portrait received its ultimate resurrection when it was propelled to world fame by its central role in Donna Tartt's Pulitzer Prize–winning novel, *The Goldfinch*, from 2013.

If you want to see the painting in person, you'll need to visit the Mauritshuis in The Hague in the Netherlands. Just make sure first that it's not out on loan as a main attraction at another big art museum.

You'll find the goldfinch itself—the wild bird, that is—in verdant deciduous forests and gardens near open farmland.

The first time you have the luck of encountering the bird close enough to really see its plumage, you'd be forgiven for thinking it's a caged bird on the run. The bright yellow and deep red seem a little too tropical for its climate. But the goldfinch has no fugitive past. (Though it is true that goldfinches were held in cages for their looks and their lively song, just like in the Fabritius painting, in other words.)

The bird's favorite food is thistle and burdock seeds. In the fall, railroad track beds, roadside ditches, demolition lots, and other gravel wastelands where these thorny plants thrive are excellent sites for goldfinch watching. The seeds may be unusually well barricaded behind the thorns, but evolution has made sure that the goldfinch beak is unusually thin and tweezers-sharp.

In general, winter is by far the best time to see goldfinches, because even though many of them migrate during the colder months, the large number that stay behind are more than happy to visit bird feeders. It was probably the thought of birdseed that brought a goldfinch to emergency physician Erika Wålander's home:

It's the only time I've seen a goldfinch in person. I noticed it sitting in a bush outside our house, just sixteen feet from the window. A goldfinch! I called. Klara! Klara! I picked up our almost two-year-old daughter, and then the two of us stood there, watching. "Inch! Inch!" she said. I thought of getting my camera, but chose not to leave. The bird stayed for another minute or so, then it left. We didn't see it again. Klara talked about the "inch" all morning. She knows six birds now: magpie, boo tit (blue tit), rooster, esan (pheasant), iskin, (siskin), and inch.

We're going to feed birds again next winter. And I'm going to look up what the goldfinch's favorite food is.

234

235

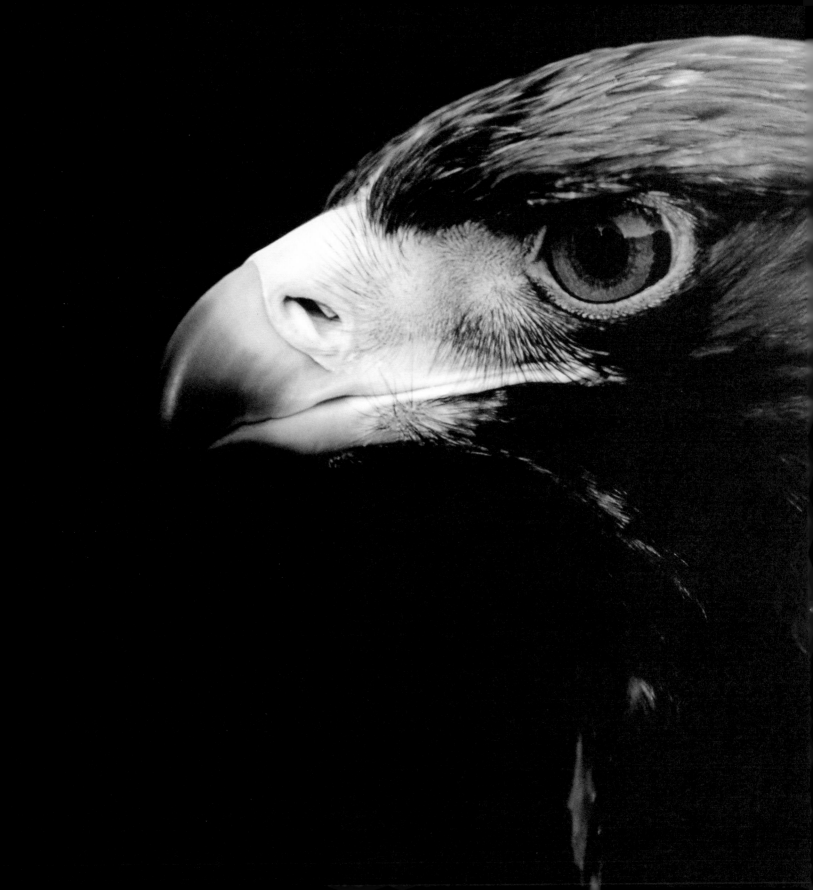

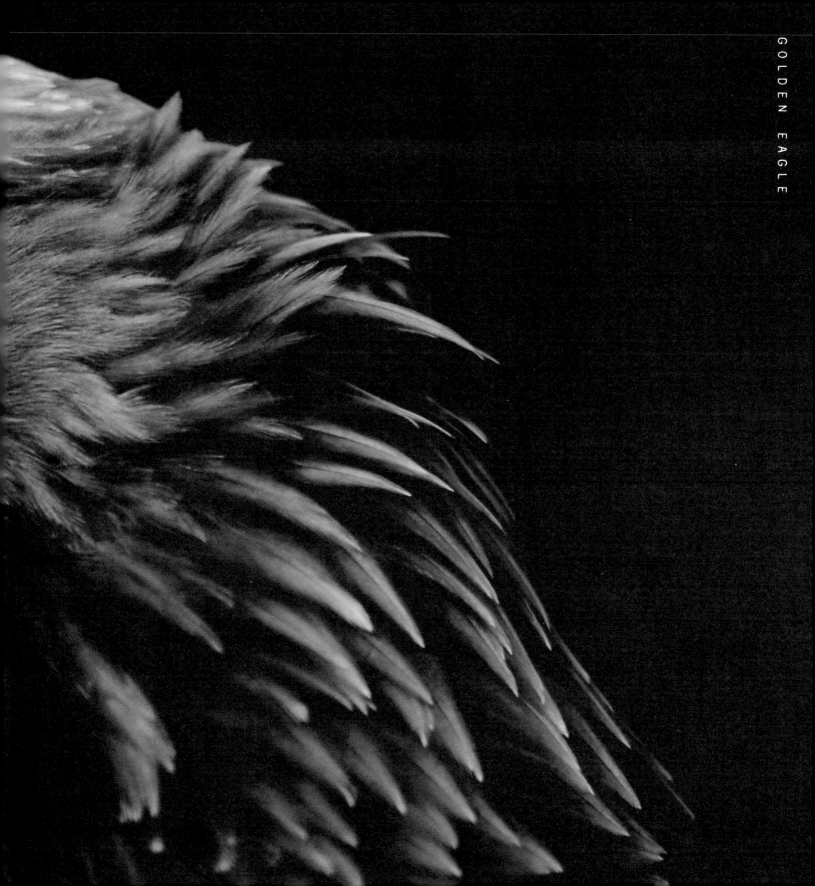

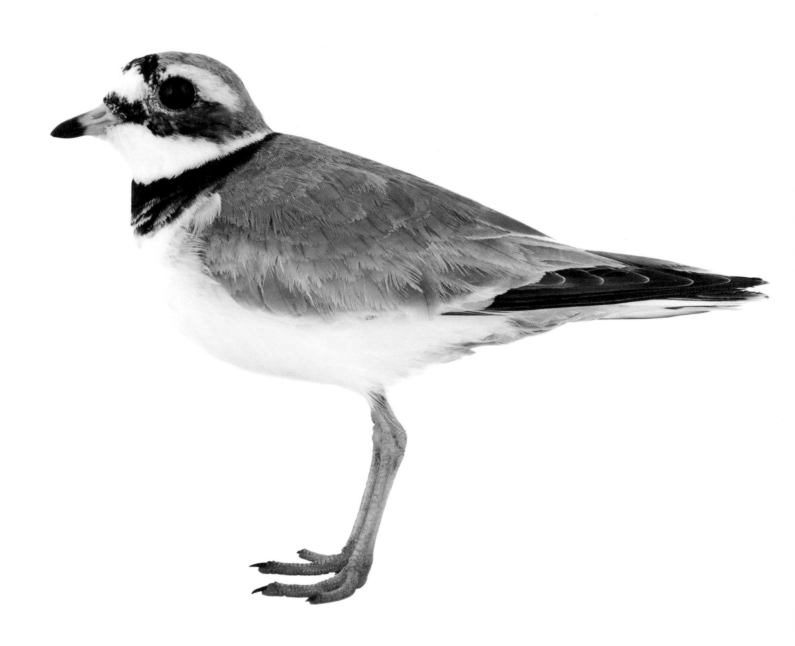

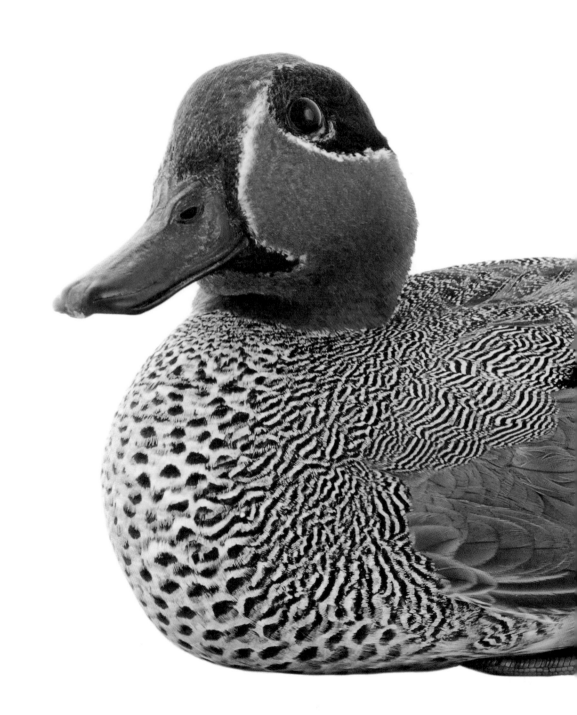

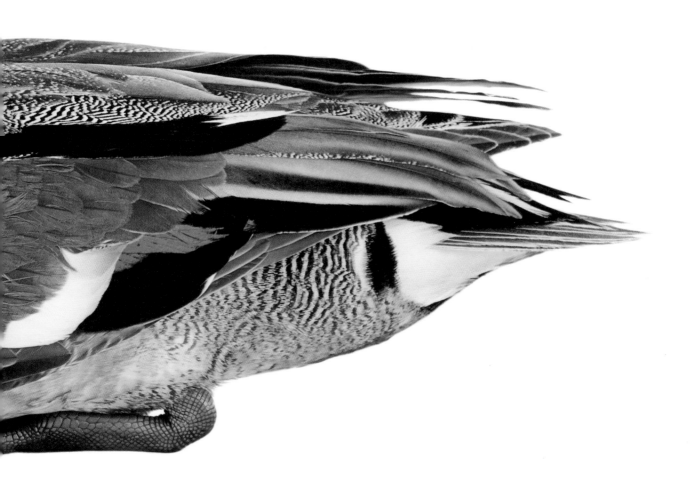

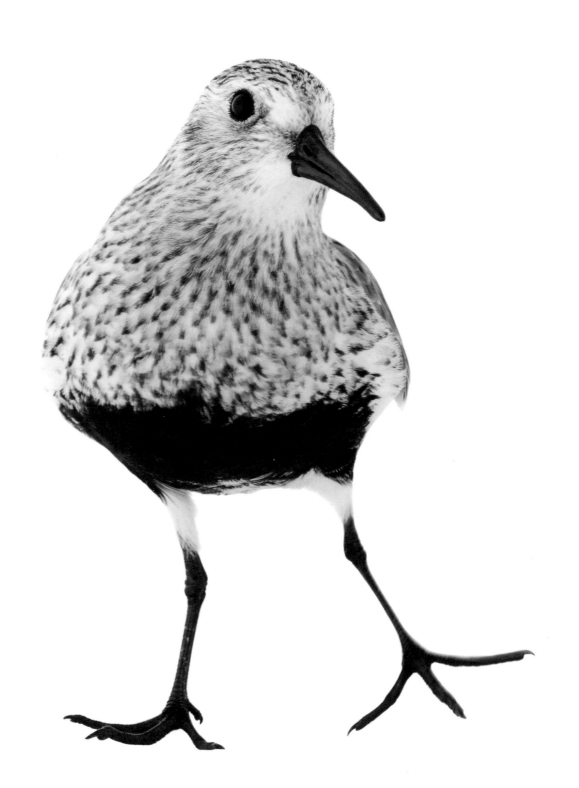

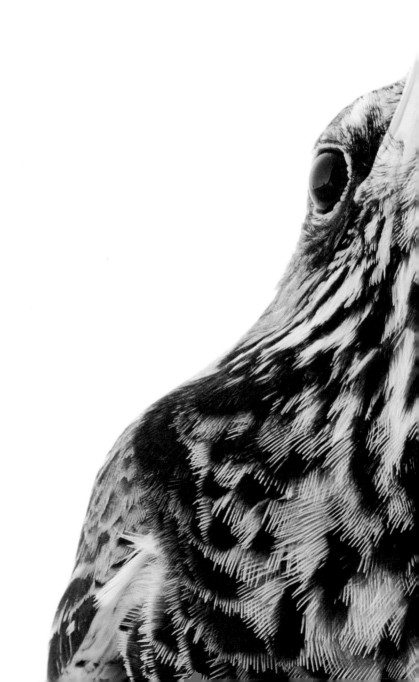

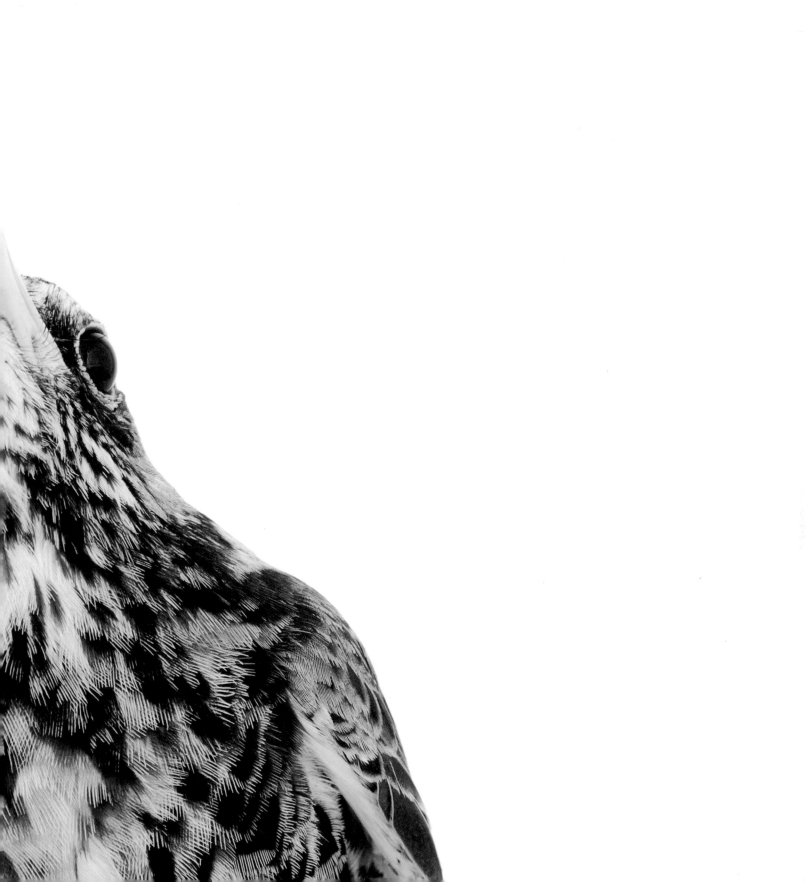

$$\frac{\begin{array}{r}2\\4\\6\end{array}}{\begin{array}{r}2\\4\\7\end{array}}$$

GETTING CLOSE TO BIRDS

The morning light is soft, and a hardy east wind wraps around the lighthouse. Photographer Roine Magnusson parks his car next to Ottenby bird station in southeastern Sweden. It is early May, and the clock has yet to strike 4 a.m. Roine takes one last sip of his coffee before he unloads the rolling camera bag full of gear and brings it to the bird observatory. He's set up a temporary photo studio in a tiny room behind the birdbanding lab. On-site already are two different sizes of wire boxes covered in white fabric. In addition to these so-called light tents, he needs his camera, reflector, and a couple of different flashes. All of these pieces come quickly out of the rolling bag. Soft down feathers dance like dust in the corners.

The preparations are routine at this point. Roine Magnusson has entered his fourth month as a roving bird portrait photographer. He's visited two other bird observatories, as well as a few wildlife preserves. Now, thousands of exposures later, the bird project is nearing its end.

Collaborating with bird observatories was an obvious approach to get close to birds. Roine himself was a devoted birder in his youth and periodically worked doing birdbanding. He's no stranger to close encounters with birds. Being hands-on is necessary both for banding and photographing birds with the method he's chosen here.

Roine and the banders jog out to check the mist nets and funnel traps as a large flock of barnacle geese pass far overhead on the way to their mating sites in the north. The small number of birds caught in the traps

this morning are carefully placed in dark canvas bags where they quickly settle down. Next, they're brought to the banding lab, where they're taken out one by one. A band is placed around the leg of every bird, which is then weighed and measured according to standards agreed upon by all bird observatories in Sweden. Once all this is done, they're released. Unless they are selected for posing, that is.

Roine receives a bag that contains a redstart and brings it to the tiny, nearly blacked-out photo studio. He sits on a stool, carefully places the bird in the box, and hangs a shawl across the circular opening in order to block as much light as possible. A few brief flaps of the wing. Then silence. Roine has just enough visibility to focus his camera. The flash goes off a few times, he makes quick adjustments to the camera settings, and then the flash again.

Roine's photo technique has been developed with the aim of being as unobtrusive as possible. It has to be quick; he only gets a minute or so with each bird before releasing them.

Initially he tried to photograph the birds outside, but they were anxious and fluttery in the light tents. It might have been too bright, so Roine covered the boxes with blackout fabric. The first bird he let out in the new darkness—a blue tit—was entirely still. Roine took a few pictures. The plumage, the gaze; it was perfect.

"Such a beauty!" he says. "The bird was like an emerald. That's when I knew that this was going to work out."

It wasn't just the crown jewels among the birds that showed their beauty in the light tent—just look at the discreet but refined coloring of the female bullfinch (pages 212–213), or the intriguing shades of brown and gray in the plumage of the house sparrow (page 131). (The house sparrow also turned out to be particularly talented at escaping the box.)

But more than the technology, he had to find those bird individuals who were most relaxed in the light tent. A peaceful bird will act more natural, and this is necessary to capture the personality of each individual and do justice to the character of the species. Roine immediately released those that were too anxious or sat unmoving with their back against the camera.

"But most were actually happy to pose," he says.

The handsome bluethroat puffed up its chest. The redstart also knew how to carry itself. The shorebirds seemed particularly well-suited to model, preening and sauntering around the box as though they were examining it.

Like the black and white pied avocet, with its thin, curved beak. This was Roine's impossible dream when the project first started. He imagined the photograph: like a Chinese ink wash painting, black on a thin white scroll. But he also knew that the avocet would be impossibly hard to get hold of.

So, he was entirely unprepared when the banders from Ottenby called well after he'd packed up and returned to his temporary bedroom to sleep.

"Roine, you might want to come over here!"

WORKS CITED

David Abram, *Becoming Animal*; Bengt Anderberg, "Det omöjliga" / "The Impossible" from *Fritt efter naturen* (excerpt translated by Kira Josefsson), Simon Armitage and Tim Dee, *The Poetry of Birds*; Werner Aspenström, "Gråsparven" from *Ordbok* (excerpt translated by Kira Josefsson); W. H. Auden, "Short Ode to the Cuckoo" from *Collected Poems*; Björn Berglund, *Mamma i Skogen / Mom in the Forest* (excerpt translated by Kira Josefsson); Staffan Börjesson, *Fågelmusik—ett tema med variationer / Birdsong: A Theme with Variations* (excerpt translated by Kira Josefsson); E. E. Cummings, from *Complete Poems 1913–1962*; Kirsten Dierking, "Nuthatch" from *Tether*; Ted Hughes, "Swifts" from *Collected Poems*; Kathleen Jamie, *Findings*; Lars Jonsson, *Vinterfåglar / Winter Birds*; Carl Linnaeus, *Carl Linnaei Skånska resa / Carl Linnaeus's Journey to Skåne* (excerpt translated by Kira Josefsson); Kathleen Dean Moore, *Wild Comfort*; Iris Murdoch, *The Sovereignty of Good*; Mary Oliver, "Winter and the Nuthatch" from *Red Bird*; Björn von Rosen, *Samtal med en nötväcka / Conversations with a Nuthatch* (excerpt translated by Kira Josefsson); Erik Rosenberg, *Fåglar i Sverige / Birds in Sweden* (excerpt translated by Kira Josefsson); Sten Selander, "En majmorgon" from *Mark och människa* and "Sädesärlorna" from *Sommarnatten* (excerpts translated by Kira Josefsson); Nan Shepherd, *The Living Mountain*; Ingrid Sjöstrand, from *Skogen i trädet* and *Shorts* (excerpts translated by Kira Josefsson); Joar Tiberg, from *Fåglar i förorten – med Finnskogen och södra Indien*.

ABOUT THE CONTRIBUTORS

ROINE MAGNUSSON is an award-winning photographer who has contributed work to *National Geographic* and has published several photography books in Sweden. He seeks unconventional ways of approaching every picture he takes and is happy to carry many pounds of camera equipment into the forest to get the image he wants.

MATS AND ÅSA OTTOSSON are freelance journalists, authors, and lecturers with a deep love for nature. They have written more than twenty books, collaborating with Roine Magnusson on the award-winning book *Cows: A Love Story*. Mats writes Bonnier's popular annual bird almanac, *Bird Diary*, and is one of the hosts of the show *Morning with Nature* on Swedish Public Radio.

KIRA JOSEFSSON is a writer, editor, and literary translator working between English and Swedish. She was awarded a PEN/Heim Translation Fund Grant for her work on Pooneh Rohi's *The Arab*, an excerpt of which was published by Granta. She lives in New York, where she serves as translation productions editor for Anomaly and on the editorial board for Glänta.